The Mauritshuis

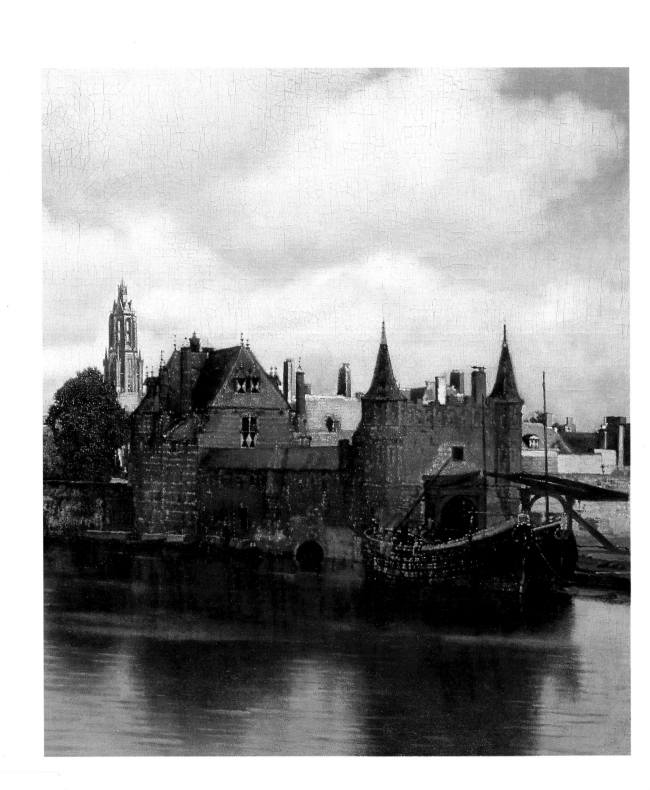

The Mauritshuis

Royal Cabinet of Paintings
Mauritshuis and
Gallery Prince William V

Ben Broos

Scala Books

© 1994 Scala Publications, London / The Mauritshuis, The Hague

First published 1994 by
Scala Publications Limited
26 Litchfield Street
London WC2H 9NJ

Distributed in Canada and the USA by
Antique Collectors' Club Ltd
Market Street Industrial Park
Wappingers Falls
NY 12590
USA

ISBN 1 85759 031 7 (hardback)

ISBN 1 85759 032 5 (paperback)

© Photos The Mauritshuis
Translated from the Dutch by Phil Goddard
Edited by Quentin Buvelot and Jane Havell
Designed and typeset by Robin Forster (art²g⁰)
Produced by Scala Publications Limited
Printed and bound by Grafiche Milani, Milan, Italy

Cover: **Jan Davidsz de Heem**
 Vase with flowers, c. 1670

Frontispiece: **Johannes Vermeer**
 View of Delft (detail), c. 1660

Contents

Introduction

The Royal Cabinet of Paintings Mauritshuis

The core of the paintings in the Mauritshuis forms what is effectively the oldest national collection in the Netherlands. The House of Orange directly or indirectly contributed to the formation of what is now an internationally famous collection, centred on Vermeer's *View of Delft* and Rembrandt's *Anatomy lesson of Dr Nicolaes Tulp*. Jan Gossaert's *Portrait of Floris van Egmond, Count of Buren* (illustration p. 34), painted in 1519, was an old family heirloom. It became part of the collection after William I, Prince of Orange, married Floris's granddaughter, Anna van Buren.

What remained of the collections of the Stadholders (governors of the United Provinces) in the seventeenth and eighteenth centuries was eventually combined in the early nineteenth century to form the Royal Cabinet of Paintings Mauritshuis in The Hague. The subsequent acquisitions of King William I made a particularly important contribution to this museum, that has enjoyed an international reputation for more than a century.

Johan Maurits and the Mauritshuis

The Mauritshuis owes its name to Johan Maurits, Count of Nassau-Siegen (1604-1679), who had it built as his residence in The Hague (illustration 1). Johan Maurits joined the State army in 1621 and took part in the siege of Den Bosch in 1629, which earned his uncle, the Stadholder Frederick Henry, the name 'conqueror of cities'. Johan Maurits's own greatest military achievement was the conquest of the Schenkenschans, near Elten, in 1636. In the same year, the Lords XIX of the West India Company decided to appoint a governor of their colony in Brazil, which had just been captured from the Portuguese. Johan Maurits, a successful soldier, was given this task and carried it out with great dedication. He governed the colony as an enlightened monarch until 1644, interested in the country not only as a source of profit, but also for its people, flora and fauna. The retinue of 'Maurits the Brazilian', as he was eventually nicknamed, included scholars and artists who shared his enthusiasm. Among them were the naturalist Georg Markgraf, the doctor Willem Piso, and the painters Frans Post and Albert Eckhout who portrayed the people, animals and plants of Brazil with uninhibited realism (illustration p. 126). Johan Maurits's seven-year period as governor is still commemorated in the former colony.

During the second quarter of the seventeenth century, The Hague enjoyed its own golden age. After their marriage in 1625, Stadholder Frederick Henry and his wife Amalia van Solms (illustration 2) gathered together a court which enjoyed an international cultural reputation. The 'conqueror of cities' became an important patron, building one residence after another in and around The Hague: Honselaarsdijk (c. 1632), the Huis ter Nieuburch (1633-1638), the Paleis Noordeinde (1641 onwards), and the Huis ten Bosch (completed in 1652). The architects for these projects were Jacob van Campen and Pieter Post, the brother of Frans Post. The designs were produced in close cooperation with Constantijn Huygens, Frederick Henry's secretary. A true humanist, Huygens was devoted to music, poetry and architecture, and had a great interest in the visual arts (illustration 3 and p. 95).

At Frederick Henry's instigation, Constantijn Huygens and Johan Maurits were given possession of a conveniently located area of land in The Hague, behind the Binnenhof on the Hofvijver. Huygens's own house was completed in 1637 and, as Johan Maurits had already left for Brazil, Huygens supervised the building of his neighbour's house. A stately home was constructed on the former 'roundel' beside the so-called 'Ministerstorentje', solidly built in strict classical style to a design by Jacob van Campen and Pieter Post. The governors of the West India Company scathingly dubbed this the 'maison du sucre'. They thought that the owner had derived too great a

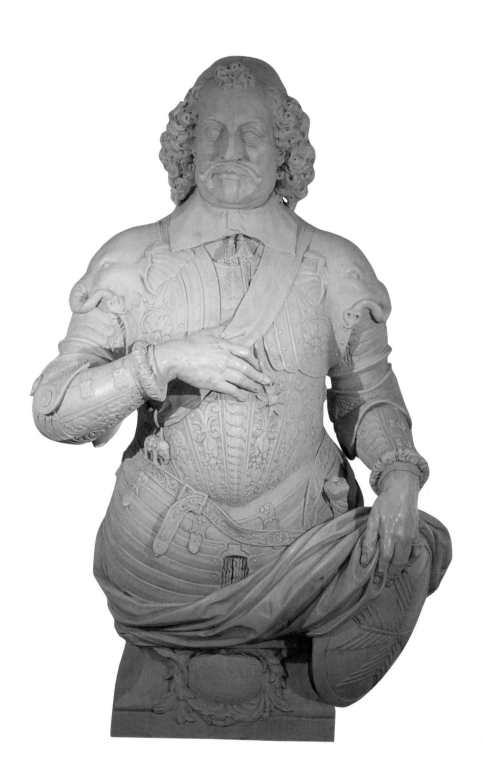

1 Copy after Bartholomeus Eggers
Bust of Johan Maurits, 1664
Marble, 132 cm high
(1987)
Inv. no. KN 20

personal benefit from the Brazilian sugar plantations, an accusation Maurits disputed.

The Mauritshuis is still regarded as a jewel of Dutch baroque architecture. The front and rear façades are strictly symmetrical. Above the entrance is a central Bentheim sandstone resalient crowned by a pediment filled with reliefs (illustrations 4-5). The row of huge pilasters is repeated in the side bays, crowned with Ionic capitals, and the rear façade is almost identical, but with a slightly larger pediment. The proportions and ground plans were also based on classical designs. The interiors were designed by Pieter Post, and his drawings are the only illustrations of the inside of the house (illustration 6).

The only written description of the inside of the house dates from 1681 and is by one Jacob de Hennin, who was overawed by the magnificence of the building. Paintings of Brazilian landscapes and exotic peoples hung on the staircases, and the main hall on the first floor housed a display of *naturalia* and *arteficialia*: household objects from the western colonies, stuffed animals, treated animal hides, musical instruments, Indian weapons, jewellery, shells and coral, ores, and precious metals and stones. It must have been a veritable cornucopia of rarities, not unlike that depicted in Jan van Kessel's picture *America* (illustration 7).

The Eighteenth Century

When Johan Maurits died in 1679, his creditors leased the house to the States of Holland. Johan Maurits had already given away most of the collection of Braziliana as diplomatic gifts, or sold them to the Great Elector of Brandenburg, Frederick III of Denmark and King Louis XIV of France. The Mauritshuis became an ambassadorial residence. On Christmas night 1704 a careless servant started a fire which destroyed the building, leaving only the walls. Fortunately, it was decided that the house would be rebuilt and, as was common practice at the time, a number of lotteries were held to raise funds. These were not particularly successful, and the restoration of the building dragged on from 1705 to 1720.

The interior was adapted to the needs of the time, with larger windows and a more spacious-looking staircase. The room at the back of the house on the ground floor became the most magnificent; it is still intact and known as the 'Golden Hall' due to its fine gilding. The hall contains murals and ceiling paintings by the itinerant Italian painter Giovanni Antonio Pellegrini (illustration 8), who joined The Hague's guild of artists in 1718 and carried out the decorations in a short space of time.

During the course of the eighteenth century, this beautiful former house, situated in one of the finest locations in The Hague, was used for a somewhat bizarre assortment of purposes. It served as a military school, and was also the venue for meetings of a poets' society entitled *Kunstliefde spaart geen vlijt* ('The love of art spares no effort'). It was not until 1822 that the Mauritshuis finally became a museum, and some of the most important items from the Stadholders' collection were subsequently displayed there.

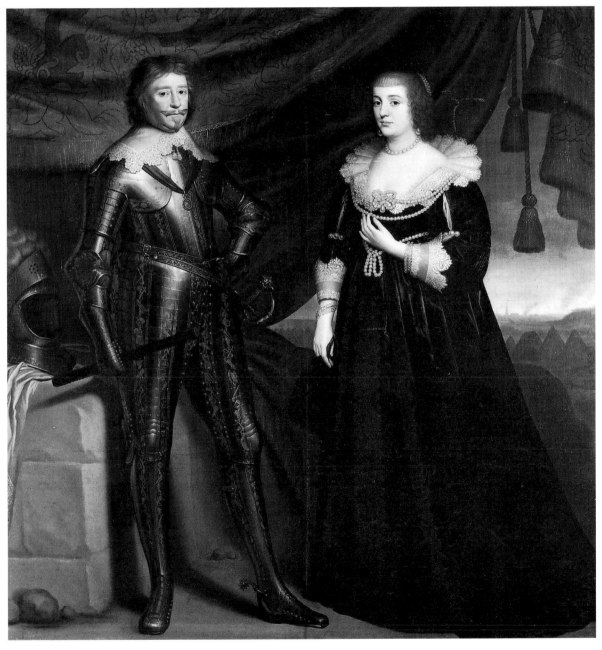

2 Gerard van Honthorst
Portrait of Frederick Henry and Amalia van Solms
Canvas, 213 x 201 cm
(1637-1638)
Inv. no. 104

The Collections

The collection now displayed in the Mauritshuis had a chequered early history. At the end of the eighteenth century, the collection of Stadholder William V was internationally renowned. The painter and art critic Joshua Reynolds wrote in his travel journal in 1781: 'Passing by Dort, Rotterdam, and Delft, where we saw no pictures, we proceeded to the Hague. The principal collection here is in the gallery of the Prince of Orange, in which are many excellent pictures, principally of the Dutch school.' Reynolds was fascinated by the paintings of horses by Philips Wouwerman, and he praised the portraits by Rubens, Van Dyck, Rembrandt and Holbein. These works are still very popular, attracting many foreign visitors to The Hague.

The original Orange collection was mainly assembled by Frederick Henry and William III, but prior to the mid-eighteenth century it had been drastically reduced as works were bequeathed and sold. For example, Frederick Henry had commissioned Rembrandt to paint a series of Passion scenes, which later came into German hands when the Princesses of Orange married. The same happened to masterpieces by the Flemish artists Rubens and Van Dyck, and the Utrecht court artists Bloemaert and Van Honthorst, which now belong to leading foreign collections. The only work by Abraham Bloemaert originally in Frederick Henry's residence of Honselaarsdijk that has remained in The Hague is the mantel painting *Theagenes and Chariclea*, once part of a series of paintings from the *Historiae Aethiopicae* commemorating Frederick Henry's marriage to Amalia van Solms.

Between 1690 and 1700, Stadholder King William III had added to the Orange collection a number of works he had bought since 1677 and assembled them at his hunting lodge at Het Loo. Here he had set up a gallery especially for these paintings, and also added works of art he had brought back from England after he became king in 1689. England's Queen Anne later asked for the return of these paintings, but was unsuccessful: as a result, the famous portraits of falconers by Hans Holbein (illustrations p. 42) and *The young mother* by Gerard Dou (illustration p. 103) remained permanently in the Netherlands (the latter had been given as a diplomatic gift by the States of Holland and West Friesland to King Charles II).

The collection in William III's gallery in Het Loo was short-lived. In 1713, those paintings which were not nailed to the panels in the rooms of Het Loo palace were publicly auctioned in Amsterdam: William III's heiress, the widow of Johan Willem Friso, was forced to sell them to pay off heavy debts. The pictures claimed by the English crown were detained. Those works from the Orange collection which remained, after this auction and the winding-up of the estates of Frederick Henry's daughters, were added to by William IV who made a few important purchases. In 1733, for example, he bought Rembrandt's *Simeon's song of praise* (illustration p. 98) to match Gerard Dou's *Young mother*. William IV also bought the monumental *Bull* by Paulus Potter (illustration p. 120), which was regarded as his greatest masterpiece.

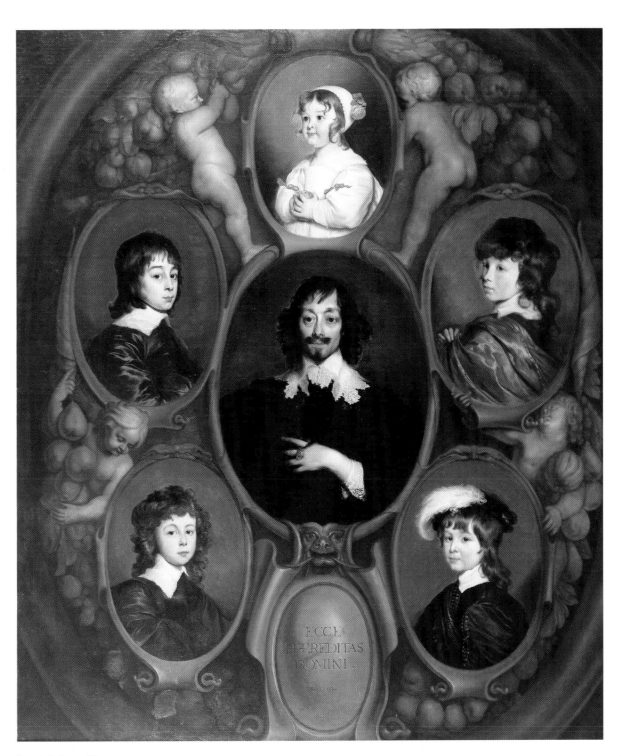

3 Adriaen Hanneman
Portrait of Constantijn Huygens and his children
Canvas, 204 x 173 cm
Bottom centre: *Anno 1640*
Inv. no. 241

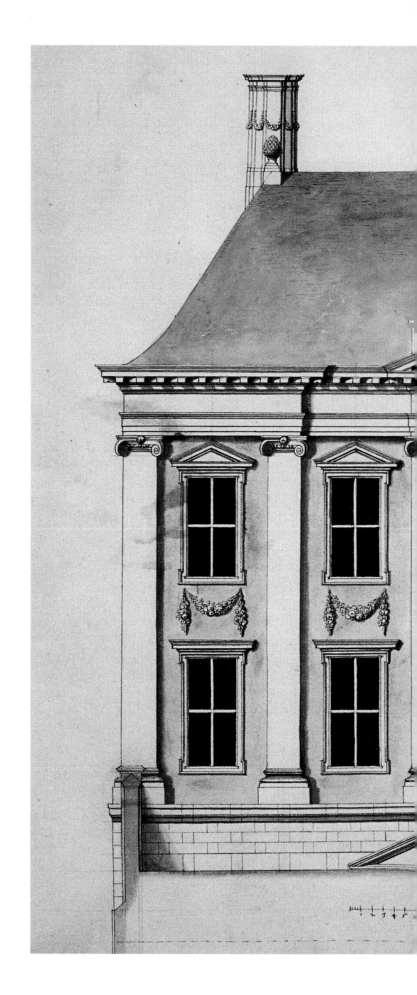

4 Pieter Post
Front façade of the Mauritshuis
Drawing, 419 x 535 mm
(1652)
The Hague, Koninklijke
Bibliotheek, inv. no. 128 A 34

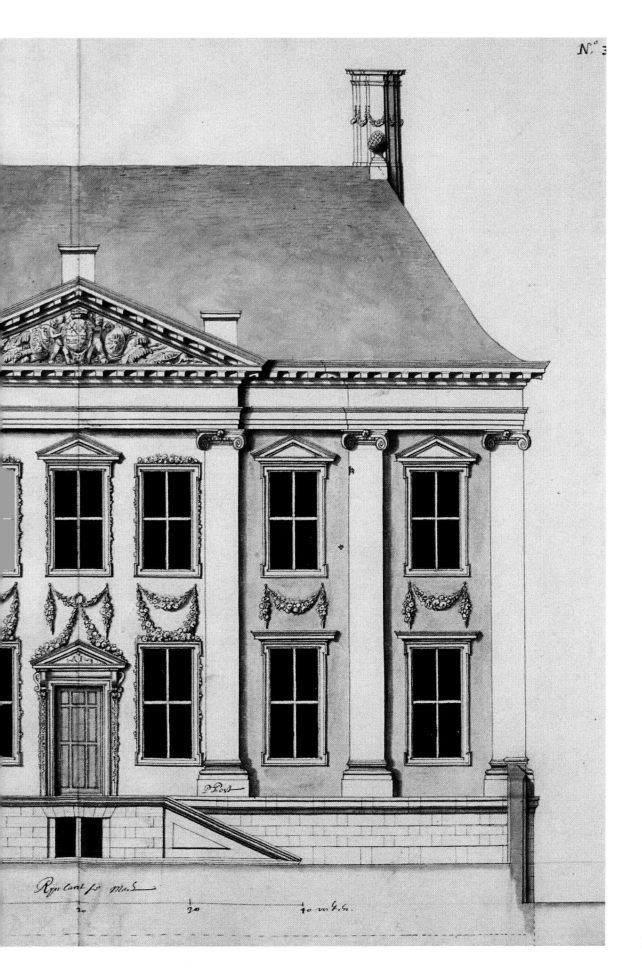

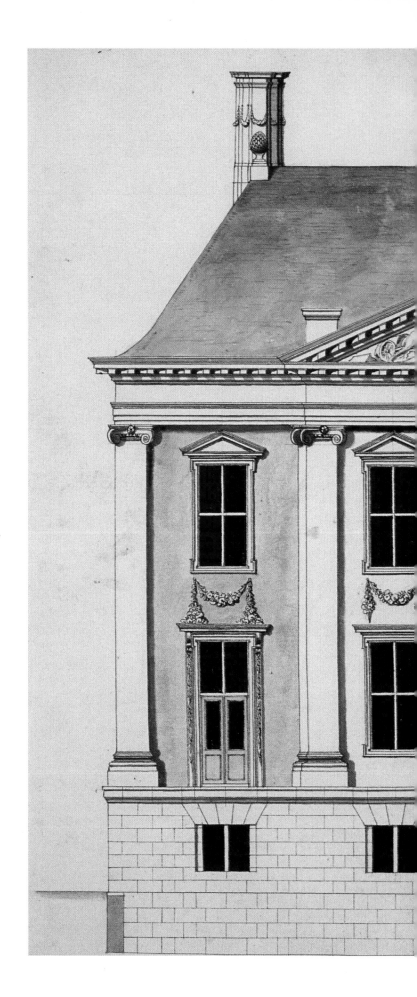

5 Pieter Post
Rear façade of the Mauritshuis
Drawing, 419 x 535 mm
(1652)
The Hague, Koninklijke
Bibliotheek, inv. no. 128 A 34

14

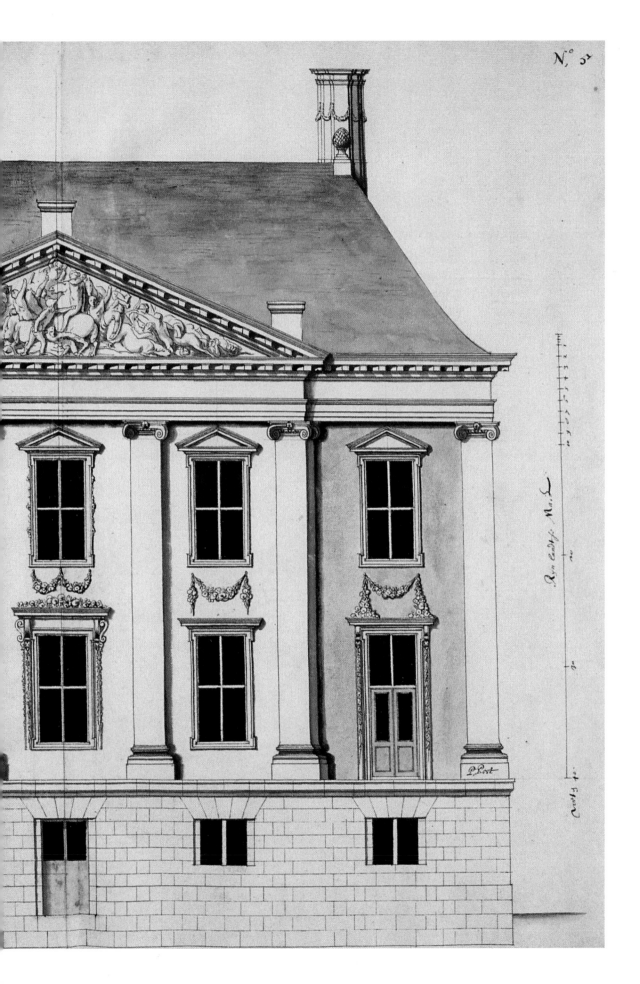

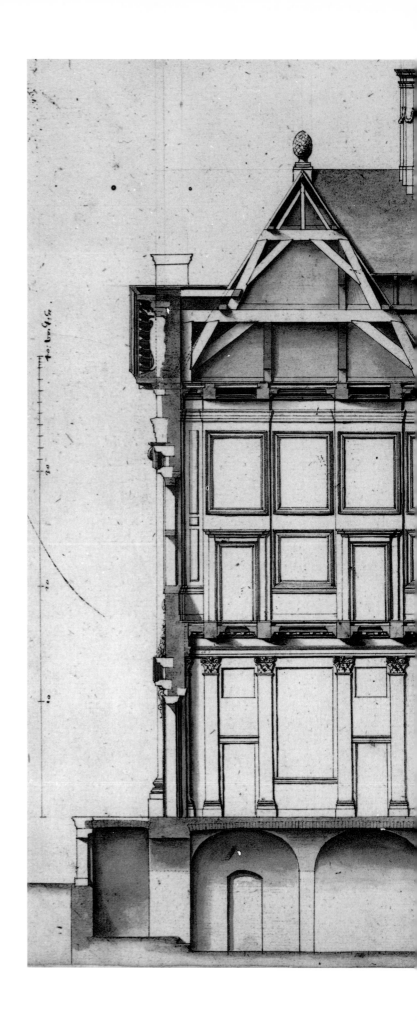

6 Pieter Post
Interior of the Mauritshuis
Drawing, 419 x 535 mm
(1652)
The Hague, Koninklijke
Bibliotheek, inv. no. 128 A 34

16

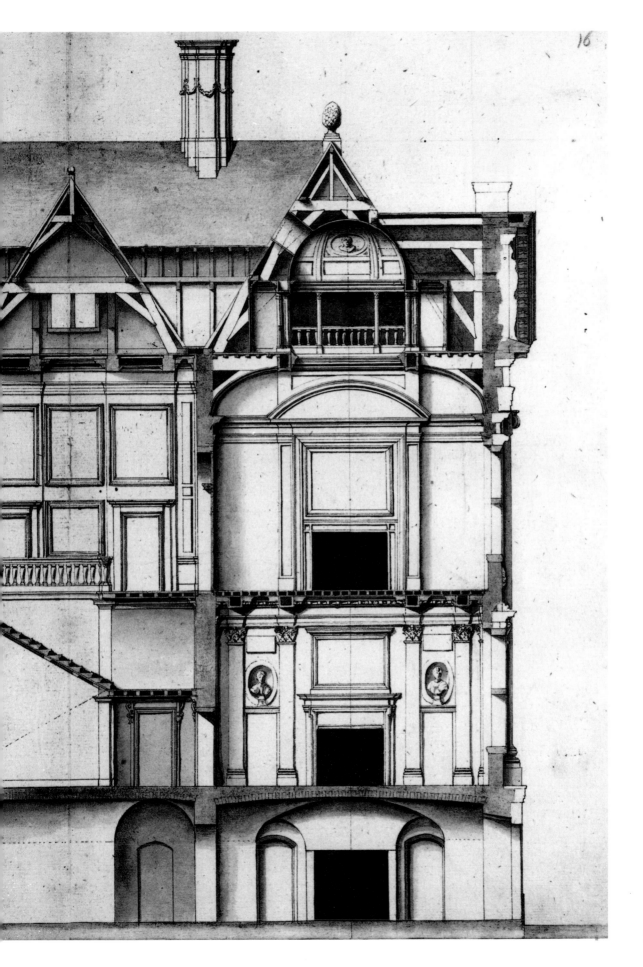

Stadholder William V & the oldest 'museum' in the Netherlands

William V (illustration 9) was the first prince of Orange to buy paintings with a view to forming a national collection rather than simply to decorate his own palaces. In 1765, he paid a very high price for Willem van Haecht's *Apelles painting Campaspe* at the King of Poland's auction (illustration p. 63). This depicts an art collection hung in the manner typical of the time, which William V must have seen as an ideal for his own art gallery. His collection would have been displayed in something like this way, placed close together from floor to ceiling, and arranged symmetrically wherever possible (illustration 10).

William V assembled an imposing collection of paintings which gave a princely splendour to his role as Stadholder. He also followed a trend set by many foreign courts by creating a collection of coins, cut stones and antiquities, and another of natural objects and other curiosities. Most of his acquisitions were made between 1764 and 1774, showing a particular interest in works by masters from Holland's Golden Age. These were added to the core of the collection, which consisted of old family portraits and works from the remains of the Orange collection.

The Dutch court became very active on the national art market again after 1760. William V bought his first painting at the age of fifteen: *The adoration of the Kings*, believed to be a work by Rembrandt's pupil Gerbrand van den Eeckhout but now ascribed to Salomon Koninck (illustration 11). One subject dear to the heart of a prince of Orange was obviously Gerard Houckgeest's *The tomb of William of Orange in Delft* (illustration p. 70), which William V bought in 1764. Another painting bought for historical reasons, ten years later, was the so-called *Poultry yard* by Jan Steen (illustration p. 82). The wily seller managed to persuade the stadholder that this painting included a portrait of one of the princesses of Orange.

William V achieved a major coup in 1768, when the Van Slingelandt collection was sold. Govert van Slingelandt was a discerning collector who had assembled forty major works and decided this was the maximum number he wanted. He continued to improve its quality by buying, selling and exchanging paintings. As well as having a passion for art himself, he also wanted to ensure that as many art-lovers as possible could enjoy his collection after his death. His widow, however, sold the whole collection to the young Stadholder William V, who thus acquired three Rembrandts in one fell swoop (illustrations pp. 97 and 99). In doing so, he narrowly beat Empress Catharine the Great of Russia, who was also fond of buying up entire art collections.

William V decided to open his art collection to the public, an unusual move at a time when art was regarded mainly as private property. The court artist T.P.C Haag, who had been giving the prince drawing lessons since 1760, advised on the setting up of a purpose-built gallery, which was the first of its kind in the Netherlands. On the Buitenhof, between the prince's cabinet of naturalia in the house 'Vijverhof' and the 'Prison Gate', a gallery of paintings was built. A long, relatively narrow room such as those widely found in Italian and English palaces and country houses, William V's gallery had a stucco ceiling in the style of Louis XVI, and contained references to the arts and sciences. It was completed in March 1774, and during that year the finest works from the Stadholder's collections were transferred from the various residences of the house of Orange (Het Loo, near Apeldoorn, the Court in Leeuwarden and Oranienstein in Germany) as well as from rooms in the Binnenhof to the new gallery.

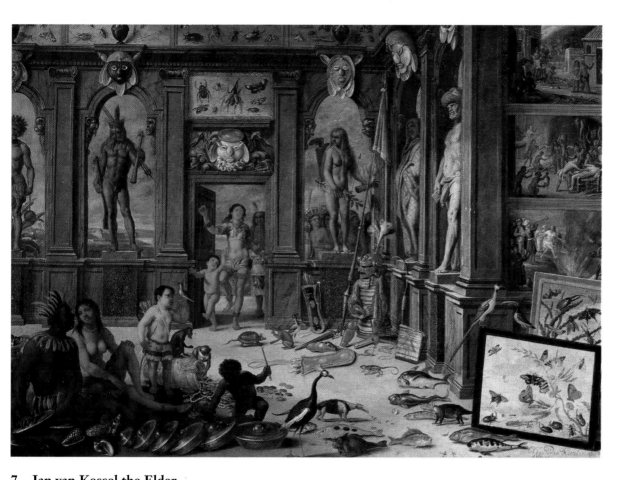

7 Jan van Kessel the Elder
America
Copper, 48.5 x 67.5 cm
Bottom right: *Jan van Kessel fecit Anno 1666*
Munich, Alte Pinakothek, inv. no. 1913

From Gallery William V to the Mauritshuis

From 1774 onwards, William V's gallery was used as a reception room for his guests, and lunches were sometimes held there. Three days a week, from 11 am to 1 pm when the light was best, the doors were opened to the public. Formal dress was not compulsory (as it was, for example, when visiting the emperor's collections in St Petersburg at the time). A modest catalogue of the 202 works on display was published. Haag, the court artist, was the gallery's first director.

The paintings on display reflected the taste of the time. Most were 'genre' pieces depicting scenes from everyday life, although there were some history paintings showing high-flown biblical or classical scenes. The collection contained almost no realistic Dutch landscapes: there was a definite preference for sunny southern scenes. There were few still lifes, while family portraits were clearly regarded as more suitable for the Prince's private rooms. But the collection did include the famous Holbein portraits of falconers, Gerard Dou's *Young mother* and the works by Rembrandt.

The collection later fell prey to the greed of the French occupying forces. On 27 March 1795 it was announced that the paintings were to be transported to Paris, 'as the property of the French Nation acquired by arms' [in translation]. As a result, leading items from the Orange collection ended up on display in Paris alongside works by Raphael and Titian plundered from Italy. In May 1795 Haag told Pictura, the fraternity of artists, 'not without sadness' that the French had begun packing up the paintings. For twenty years, French and foreign visitors were able to admire Potter's *Bull* in Paris. After this long period of being held hostage in the Louvre, around 120 paintings were returned to The Hague in 1815, amid triumphant cannon salutes and pealing of bells. Seventy paintings, however, remained in France; many are now located in provincial French museums. The *Portrait of William III in a wreath of flowers* by Jan Davidsz de Heem is now in Lyon, and Jan Mijtens' *The marriage of the Great Elector to Louise Henriette Maria of Orange* can be seen in Rennes. The Louvre still contains a major work by Gerard van Honthorst, *The concert* (illustration 12), which was originally in Noordeinde palace.

King William I, the son of Stadholder William V who became sovereign in December 1813, established a number of national institutions including the Royal Library, the Royal Cabinet of Coins and the Royal Cabinet of Paintings. The paintings were housed in William V's gallery, as his original collection had been, and comprised those which had been returned from France and a small number of recent acquisitions. The returned works were informally transferred to the State of the Netherlands. At William I's initiative, works were regularly bought for 'his' art gallery, and the collection soon outgrew the building.

In 1820, therefore, the former residence of Johan Maurits van Nassau-Siegen was purchased, and the Royal Cabinet of Paintings and Royal Cabinet of Rarities were transferred to the Mauritshuis. Jonkheer Johan Steengracht van Oostkapelle was appointed as unpaid director of the painting collection, and his paid deputy director was the artist J.W. Pieneman. It was open to the public two days a week, and on the other days was made available for study by scholars and for copying by artists.

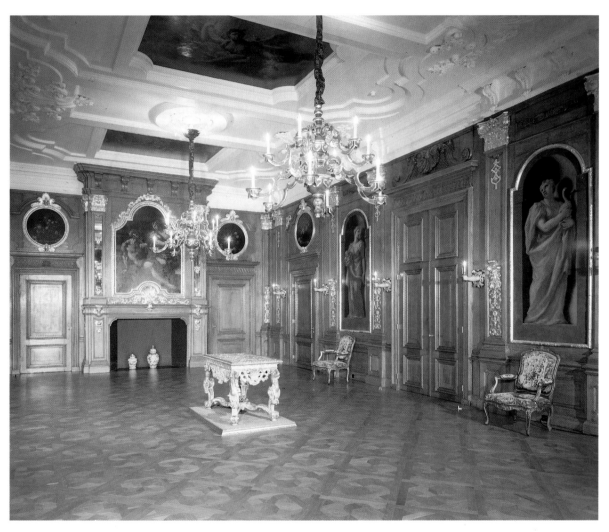

8 The 'Golden Hall' with paintings by
Giovanni Antonio Pellegrini (completed in 1718)

Acquisitions

One notable result of Steengracht's period as director was an illustrated catalogue, published in four parts and in two languages between 1826 and 1830. This contained descriptions and engravings of a hundred highlights from the collection (illustration 14). In his introduction, Steengracht wrote that the publication was a highly ambitious attempt to emulate the examples of museums in Paris and Florence. The royal family's close involvement in the changing fortunes of the collection is apparent from the dedication: 'à sa Majesté la Reine des Pays-Bas, protectrice des beaux-arts'. With justified pride, Steengracht ended his selection with Rembrandt's *The anatomy lesson of Dr Nicolaes Tulp* (illustration p. 99), recently bought for the museum by the King, who issued a decree in 1828 preventing its public auction. King William I often ordered the purchase of specific paintings, and appeared to have special funds available for this purpose. The director of the Rijksmuseum in Amsterdam, Cornelis Apostool, wrote to Steengracht on 11 June 1822 that he was sending Johannes Vermeer's *View of Delft* (illustration p. 67), recently bought at the Stinstra auction, to The Hague at the King's order.

Jacob van Ruisdael's *View of Haarlem with the bleaching-fields* (illustration p. 122) arrived at the Mauritshuis by a similar route in 1827. In the same year, William I personally bought Rogier van der Weyden's *Lamentation* (illustration p. 35) from Baron Keverberg van Kessel in Brussels, though it was then ascribed to Memling ('Hemlin'). This was something of a historic purchase, as it is still regarded as one of the leading examples of Flemish primitive painting in the Netherlands. Four of the Mauritshuis collection's most important works, therefore, were bought by William I: the *Anatomy lesson*, the *View of Delft*, the *View of Haarlem* and the *Lamentation*.

But there were also setbacks for the Mauritshuis. The financial drain caused by the Belgian rebellion was felt even in the Royal Cabinet: no further items were purchased after 1832, and under King William II there was no active interest in the collection. In 1850 and 1851 the King's private collection was sold at auction, including his extremely fine fifteenth- and sixteenth-century masterpieces. But none of these ended up in the Royal Cabinet, and the Mauritshuis had to survive for many years on an acquisitions budget of only 1,800 guilders. In 1875, the Royal Cabinet of Rarities was removed, leaving the whole building free for the paintings. The attic was found to contain a number of works which had been left to their fate and fallen prey to 'damp, heat, lack of light, air and space' [in translation].

In 1874, Victor de Stuers produced a new catalogue of the Mauritshuis collection, listing 318 paintings and 15 sculptures. In his opening sentence, De Stuers stated that the Mauritshuis collection was now one of the best in Europe: not because of the large number of paintings it contained, but because of their high quality. The famous French critic Thoré-Bürger had come to The Hague several years before to study the Dutch masters of the Golden Age, and his articles had greatly increased the popularity of works from this period. He was even described as having 'rediscovered' Vermeer, and this was certainly true for the French public. Bürger gave a somewhat dramatic description of his long journey to The Hague to see the *View of Delft* and recounted the tribulations he underwent in obtaining a photograph of it.

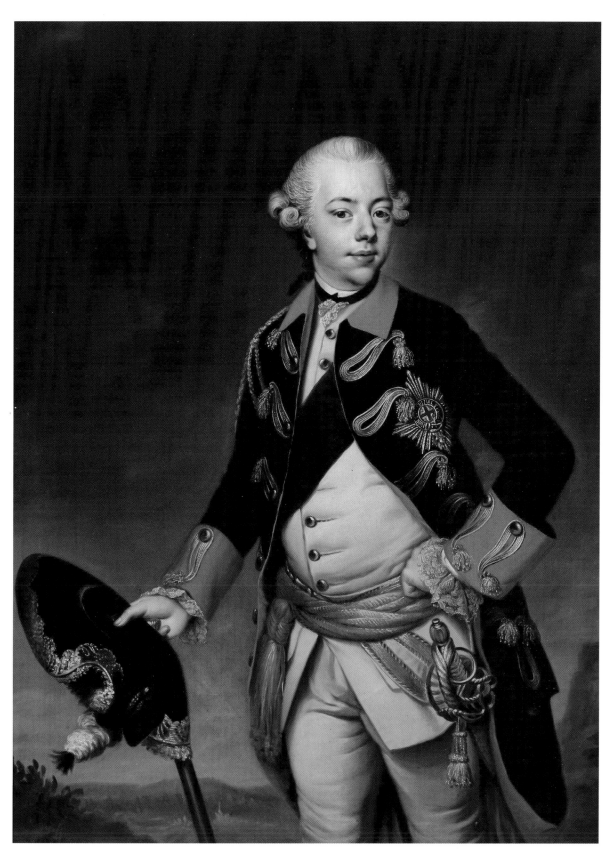

9 Johann Georg Ziesenis
Portrait of William V
Canvas, 141 x 101 cm
(c. 1770)
Inv. no. 462

Legacies

The Mauritshuis's status as an internationally recognised institution was reflected in its acquisitions policy and the publication of *catalogues raisonnés* and monographs. When Abraham Bredius became director in 1889, interesting items were regularly being added to the collection. In London in 1894 he bought a *Portrait of an unknown Italian*, believed to be a work by Antonello da Messina and never before described in the literature; this is now ascribed to Memling (illustration p. 34). Experts agreed that he had bought it for far less than its true value. With his budget of only a few thousand guilders, he was in Paris in 1896 for the auction of Carel Fabritius' *The goldfinch* (illustration p. 71). Bredius later described proudly how he had got a front man to bid because he was afraid that his interest would force the price up.

Quality increasingly became the main criterion in acquiring new items; the museum no longer sought to be comprehensive, as the Rijksmuseum already served that purpose. Supporters of the museum agreed with this policy, and the gifts it received were often of high artistic quality. In 1903, for example, it acquired a number of important works including Johannes Vermeer's *Girl with a pearl earring* (illustration p. 65). This was given by A.A. des Tombe, who had bought it for a pittance in 1882. Thanks to Des Tombe's generosity, the gallery also acquired the magnificent *Vase with flowers* by Ambrosius Bosschaert the Elder (illustration p. 49).

During Willem Martin's directorship in 1913, the Steengracht collection was auctioned. This contained a number of Dutch masters, which had long been competing with the treasures of the Mauritshuis from their home at the Vijverberg. The Rembrandt Society had by this time been formed: it was a private initiative which helped to keep works of art in the Netherlands when the government was unwilling to intervene. The Society bought five paintings for the Mauritshuis with the help of gifts from individuals, and the government provided additional loans for the purchases. As a result, the museum acquired Gerard ter Borch's *The louse hunt* (illustration p. 69) and Jan Steen's monumental '*The way you hear it is the way you sing it*' (illustration p. 83). A similar shared financial success occurred in 1925, when Isack van Ostade's *Travellers outside an inn* was purchased, which used to hang in the Wallace Collection in London. Willem Martin was justifiably proud of this acquisition. Sir Henry Deterding also made an important gift in 1936, which included Jan Steen's *The oyster-eater* (illustration p. 75).

One high point of the collection's recent history was the gift of 25 paintings from the Bredius collection, which had been on loan to the Mauritshuis for many years. The most important works were Rembrandt's *Homer* (illustration p. 100), *Saul and David* (there is some dispute as to whether this was painted by Rembrandt himself) and *The two negroes* (illustration p. 100). A special exhibition was held in 1991 to commemorate the Bredius bequest, entitled 'A tenacious director collects'.

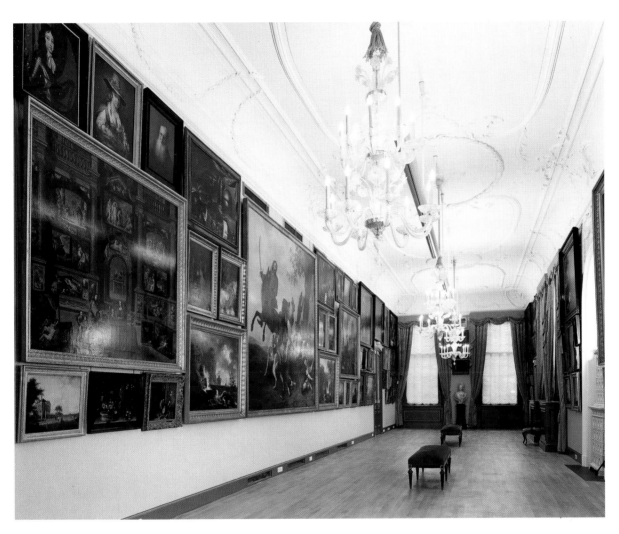

10 The Gallery Prince William V in 1994

Through new eyes

After World War II, a number of paintings were returned to the Netherlands after being seized by the German occupiers and were added to the Mauritshuis collection. The museum acquired leading works from the former Mannheimer collection, including the meticulously painted *Brothel scene* by Frans van Mieris (illustration p. 73) and Jan van der Heyden's *View of the Oudezijds Voorburgwal with the Bierkaai and the Oude Kerk in Amsterdam* (illustration p. 121). The latter is an example of the vagaries of fortune which paintings sometimes undergo before they reach the safe haven of a museum. Van der Heyden's work was bought by the well-known Delft collector Valerius Röver in 1713, from an inn in Maassluis. His widow then sold it to Wilhelm VIII of Hessen-Kassel. It was subsequently stolen from Kassel by the French, bought from the Empress Josephine by the Russian Tsar, sold by the Soviets around 1935 and placed in the Linz art gallery by the Nazis.

In 1947, Rembrandt's *Self-portrait in 1669*, the last year of his life (illustration p. 101), was bought from the Rathenau family, after it had been on loan to the Rijksmuseum before the war. Exceptional paintings such as these further increased the renown which the Mauritshuis had acquired in the eyes of art connoisseurs and the public.

The collection was given a wider focus with the acquisition of Rubens' *'Modello' for the assumption of the Virgin* (illustration p. 57) and *The adoration of the shepherds* by Jacob Jordaens (illustration p. 63). At the same time, the boundaries of the collection were defined more clearly. The museum gave all of its Italian works, and some by Spanish and French painters, to the Rijksmuseum on long-term loan. In return, it received a number of fifteenth- and sixteenth-century Flemish and German works, a collection of miniatures (illustration 13) and some seventeenth-century paintings from the southern Low Countries. This meant that Piero di Cosimo's famous portraits of Giuliano da San Gallo and his father (described in William V's collection as 'Laurens Jansz Coster' and 'Arredijn') went to Amsterdam, and Jan Gossaert's *Portrait of Floris van Egmond*, mentioned above (illustration p. 34), came to The Hague.

The most popular of the immediate post-war acquisitions include Frans Hals' *Laughing boy* (illustration p. 76), Pieter Saenredam's *The Mariaplaats and Mariakerk in Utrecht* (illustration p. 66) and probably Pieter van Anraadt's *Still life with earthenware jug and pipes* (illustration p. 112) which some visitors have mistaken for an early work by Vermeer. Many works by lesser-known artists have gained additional lustre from being displayed amid so many works by great masters; this is another of the most distinctive features of the Mauritshuis collection.

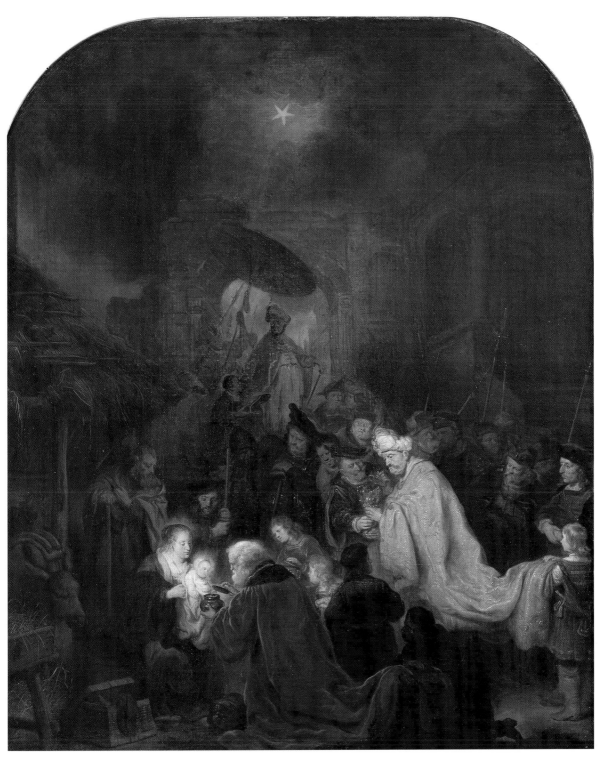

11 Salomon Koninck
The adoration of the Kings
Canvas, 81 x 66 cm
(c. 1660)
Inv. no. 36

A change of appearance

In 1982, the Mauritshuis was closed for restoration for five years. Despite periodic improvements to the interior, from a technical point of view the gallery was very antiquated. The rebuilt gallery was to include proper climate control, fire protection and storage facilities for paintings, better facilities for the public and a new library and office space. During the renovation, a selection of paintings from the collections toured in the USA, Canada, Japan and France, where they were seen by millions of people. Major works were placed on display at the Johan de Witthuis on the Kneuterdijk; others were temporarily kept in the Gallery Prince William V, which had reopened in 1977. After a considerable time being used for archive storage, the gallery was restored to its former function to give visitors an idea of the way 'the Netherlands' oldest art gallery' had looked in 1774. Between 1982 and 1987 as many paintings as possible were displayed which had been on show in 1774.

On 4 June 1987, the new and improved Mauritshuis was officially reopened by Queen Beatrix. Behind the smart new appearance and Ionic columns is a modern museum expected to continue fulfilling its purpose for many generations to come. Its greatest attraction is still its combination of a unique and historic city palace and a world-famous collection of paintings.

Recent acquisitions

A number of important new acquisitions were on display for the reopening, including the *Allegory on conjugal harmony* by Jan Sanders van Hemessen (illustration p. 47) and *Rinaldo and Armida* by the *fijnschilder* (fine painter) Willem van Mieris. These works date from the broad fringe of the Golden Age. International Mannerism was long regarded as a somewhat odd fringe phenomenon: one very fine example of this school was kept permanently under lock and key because the painting was regarded as too risqué to display. This was Joachim Wtewael's *Venus and Mars surprised by Vulcan* (illustration p. 55), which was restored and placed on display in 1987 as a 'discovery' from the museum's own stock.

The more recently established Friends of the Mauritshuis Foundation has often been of great help in buying important paintings. Two particularly high-quality works bought in this way have been *Simeon's song of praise* by Arent de Gelder (illustration p. 105) and *Isaac and Rebecca* by Gerbrand van den Eeckhout (illustration p. 104). These acquisitions helped to fill what was seen as a serious shortage of works by pupils of Rembrandt. One very surprising acquisition was the *Vase with flowers* by Jan Davidsz de Heem (illustration p. 109). This superb and wholly unknown painting on original canvas emerged from obscurity in 1993. But even more surprising was the public support given when an appeal for funds was made in the press to purchase Jacob van Campen's *Portrait of Constantijn Huygens and Suzanna van Baerle* (illustration p. 95) for the Mauritshuis. Thanks to the generosity of many people, and one donor in particular, the portrait was bought at auction in London. This initiative provided further evidence of the warm affection in which the Mauritshuis collection is held.

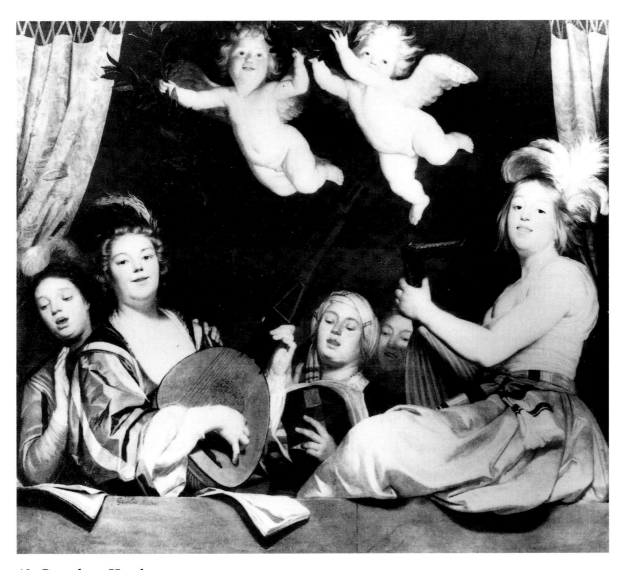

12 Gerard van Honthorst
The concert
Canvas, 168 x 178 cm
Bottom left: *G. Honthorst Fe. 1624*
Paris, Musée du Louvre, inv. no. 1364

Exhibitions

After the publications by Johan Steengracht and Victor de Stuers, a number of *catalogues raisonnés* were published and became standard works. One was produced by Abraham Bredius (and Cornelis Hofstede de Groot) in 1895; another was published by Willem Martin in 1935. There were a number of publications on specific parts of the collection (fifteenth and sixteenth centuries, Rembrandt, landscapes). 1993 saw the publication of a catalogue raisonné on the history paintings, the first part of a series on the collection of the Mauritshuis. Forthcoming are catalogues of portraits, genre paintings and still lifes, and another on landscapes.

The museum is not resting on its laurels. A number of important exhibitions have been held, including *Jan Steen* (1958-1959), *In the light of Vermeer* (1966), *Gerard ter Borch* (1974) and *Jacob van Ruisdael* (1981). Johan Maurits was commemorated with exhibitions in 1953 and 1979-1980, and a record 180,000 people visited the 1990-1991 exhibition, *Great Dutch Paintings from America*. Many visitors expressed surprise at the variety of styles and subjects in this display of seventeenth-century Dutch painting. One critic said that the general view of the Golden Age was clearly too narrow and needed to be changed. The Mauritshuis' collection policy has long reflected this broader vision.

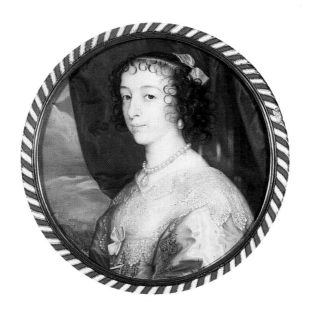

13 John Hoskins
Portrait of Queen Henrietta Maria
Parchment, diameter 17.6 cm
Bottom right: *1632 iH*
Inv. no. 1004

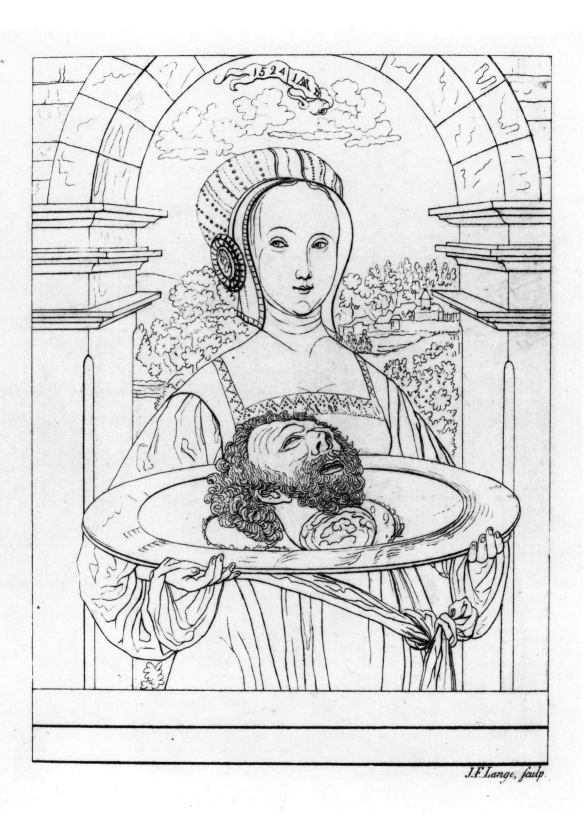

14 J.F Lange after Jacob Cornelis van Oostsanen
Salome with the head of John the Baptist
Engraving, 99 x 74 mm
From: J. Steengracht van Oostkapelle, *De voornaamste schilderijen van het Koninklijk Kabinet te 's Gravenhage*, vol. I, The Hague, 1826

Rogier van der Weyden and the Flemish primitives

'Flemish primitives' is a somewhat misleading name for the extremely fine art, mainly from the fifteenth and sixteenth centuries, produced in a larger area than the Flanders we know today. The Orange collection contained few works from this period. One curiosity was *Salome with the head of John the Baptist*, painted by Jacob Cornelis van Oostsanen in 1524 (illustration 14), long regarded as the work of Lucas van Leyden. Stadholder King William III inherited it from his aunt, Albertina Agnes of Orange, who had bought it in Antwerp as a 'Quintus Massius'. She bought a real Quinten Massys, also in Antwerp, for 600 guilders; this *Virgin and Child* is now in The Mauritshuis (illustration p. 38). The former painting was given to the Rijksmuseum in Amsterdam on long-term loan; the latter is now in the Mauritshuis as a loan from the Rijksmuseum. Such misattributions were common at this time. Another example was also part of the Orange collection for a long period. The *Portrait of Floris van Egmond*, Count of Buren (illustration p. 34), was painted by Jan Gossaert in 1519. By the seventeenth century the identity of the artist was no longer known and the painting was believed to be by Lucas van Leyden, partly because it bears a capital 'L'. This appears, however, not to have been Lucas's monogram but rather the age of the portrait's subject (L = 50).

Because of the lack of documentation or original descriptions, many unsigned panels from the fifteenth and sixteenth centuries were anonymous, and were often wrongly ascribed to Jan van Eyck, Lucas van Leyden or Albrecht Dürer. Ascribing and identifying stylistic similarities between artists and groups of artists is still the main task facing those researching the early days of oil painting. Many artists from this period are known only by acquired names such as the Master of Frankfurt (illustration p. 36), the Brunswick Monogrammist (illustration p. 37) or the Master of the Solomon Triptych. The pedigree of the triptych of this master, *The history of Solomon* (illustration p. 38), is retraceable to Willem Simonsz, mayor of Zierikzee. The painting was probably made in Antwerp between 1521 and 1525 to commemorate his marriage. Much later, his descendants gave the painting to the Mauritshuis, but by then the artist's name had been lost.

A similar fate befell works by many of the 'Flemish primitives', even if they are painted by Rogier van der Weyden. In 1827, King William I bought Van der Weyden's *Lamentation* from a Brussels baron as a work by Memling. This masterpiece had earlier been ascribed to Jan van Eyck, and only recently has scientific examination shown that the painting must almost certainly have been by Van der Weyden. Of course William I had realised its particular artistic qualities. Abraham Bredius, the former director of the Mauritshuis, must have been equally admiring in 1874 when he bid at auction for Hans Memling's *Portrait of an unknown Italian* (?) (illustration p. 34). This was ascribed to Antonello da Messina. The masters working in the southern and northern Low Countries up to about 1525 may not be represented on a very large scale in the Mauritshuis, but the works which are on display are some of the very finest examples.

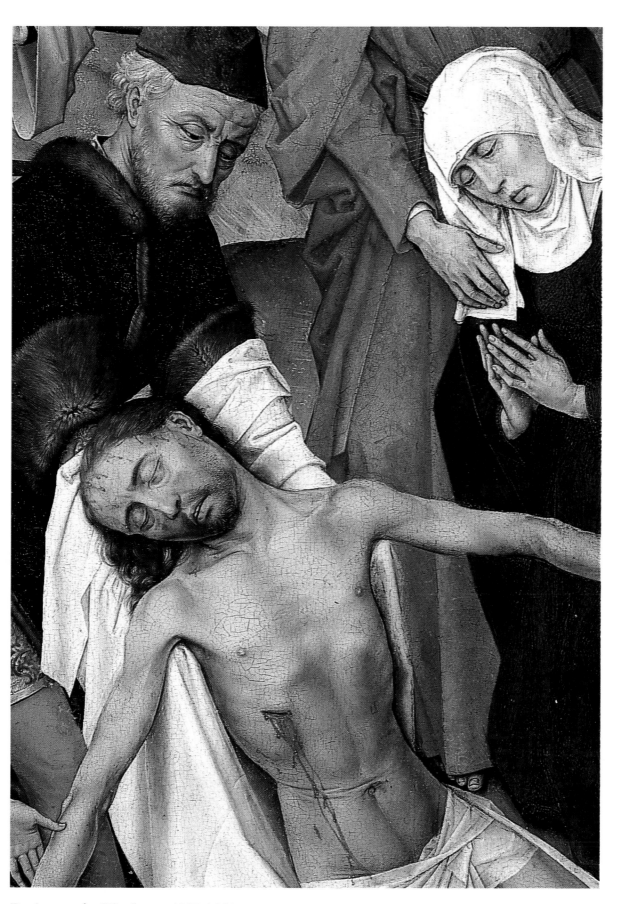

Rogier van der Weyden, c. 1399-1464
The lamentation (detail; see p. 35)

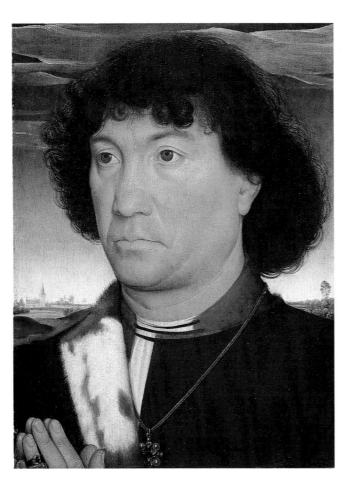

Hans Memling, 1435/1440-1491
Portrait of an unknown Italian (?), c. 1487
Panel, 30.1 x 22.3 cm
Inv. no. 595

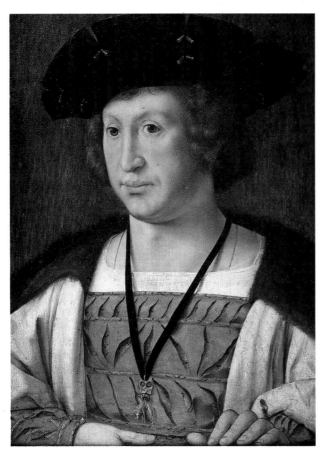

Jan Gossaert, 1478-1532
Portrait of Floris van Egmond, 1519
Panel, 39 x 29.5 cm
Inv. no. 841

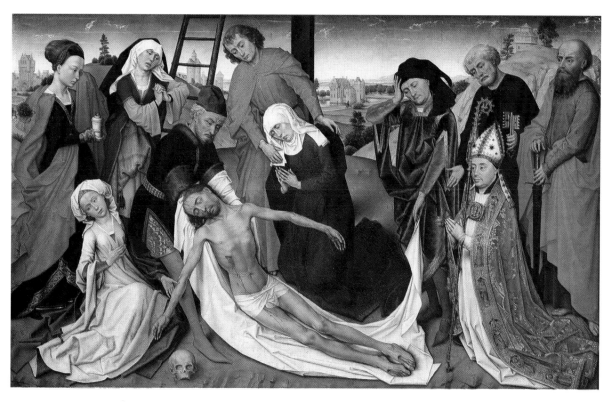

Rogier van der Weyden, c. 1399-1464
The lamentation, c. 1450
Panel, 80.5 x 129.5 cm
Inv. no. 264

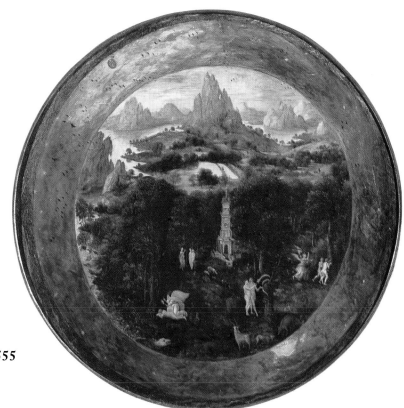

Herri met de Bles, c. 1510-after 1555
The garden of Eden, c. 1525/1530
Panel, diameter 47 cm
Inv. no. 959

35

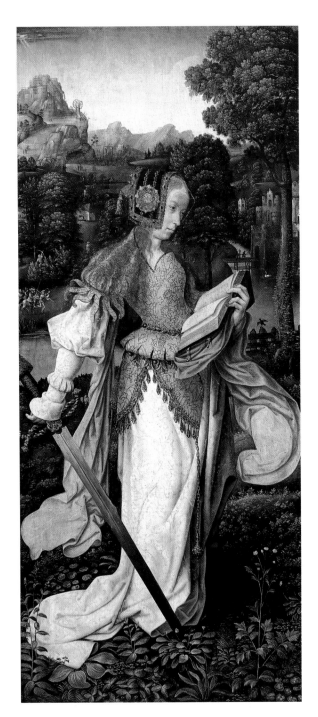
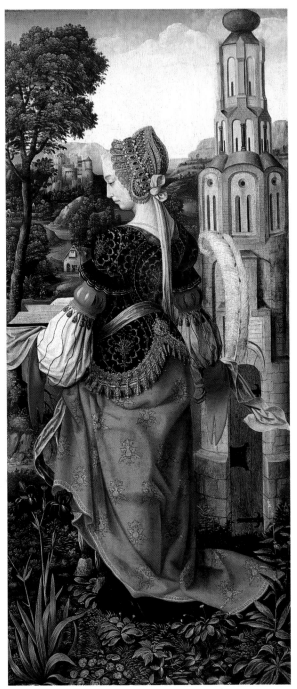

Master of Frankfurt (Hendrick van Woluwe?), c. 1460-c. 1530/1533
Saint Catherine and Saint Barbara, c. 1520
Panels, 158.9 x 70.9 cm and 158.4 x 70.6 cm respectively
Inv. nos. 854-855

**Brunswick monogrammist
(Jan van Amstel?), c. 1500–
before 1543**
Ecce Homo, c. 1540
Panel, 55.5 x 88.5 cm
Inv. no. 960

Gerard David, c. 1460-1523
Woodland landscape with donkeys and an ox,
c. 1505/1510
Panels, each 90 x 30.5 cm
Inv. no. 843

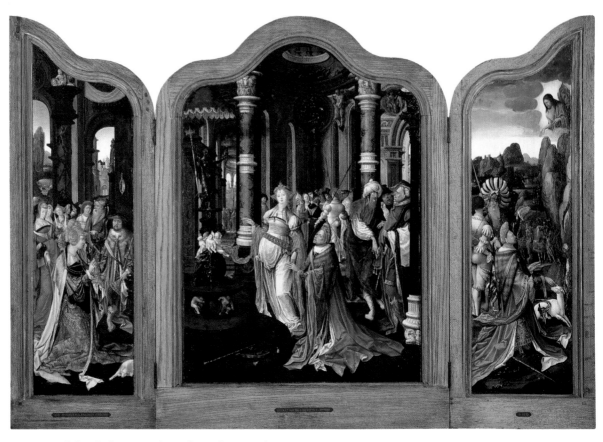

Master of the Solomon triptych, active c. 1520
The history of Solomon, after 1521/1525
Panel, 107.5 x 77 cm (centre), 107.5 x 32.5 cm (wings)
Inv. no. 433

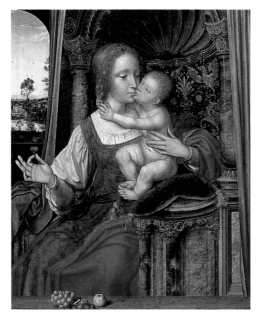

Quinten Massys, c. 1465-1530
Virgin and child, c. 1529
Panel, 75 x 63 cm
Inv. no. 842

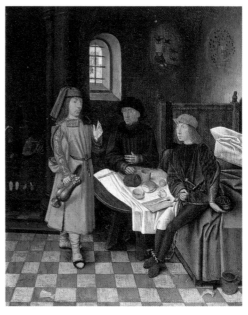

North Netherlandish school (Jan Mostaert or Jacob Jansz van Haarlem?), c. 1500
Joseph explaining the dreams of the baker and the cupbearer, c. 1500
Panel, 31.1 x 24.5 cm
Inv. no. 921

Quinten Massys, c. 1465-1530
The carrying of the cross, c. 1512/1513
Panel, 82.5 x 60 cm
Inv. no. 961

Hans Holbein and the sixteenth-century masters

2

Apart from Dutch and Flemish paintings, the Mauritshuis collection also contains some exquisite works by sixteenth-century German masters such as Holbein and Cranach, who both received international fame. This was a turbulent period of religious conflict. Hans Holbein the Younger moved to England in 1532 because of his religion, and soon made a name for himself painting portraits of rich London merchants; four years later, he was appointed court artist to King Henry VIII. In 1533, Robert Cheseman commissioned from Holbein a portrait of himself as the king's falconer (illustration p. 42). He is shown with his hair cut in a short fringe and left long over the ears, which was the court fashion at the time. In May 1535, Henry VIII ordered that older men should have beards and cut their hair short. This is reflected in Holbein's portrait of another, unknown courtier holding a hawk on his fist (illustration p. 42). He is not a leading falconer like Cheseman, but rather a country aristocrat out hunting.

Another court painter was Lucas Cranach the Elder, who worked in Wittenberg for the Saxon Electors John the Resolute and John Frederick the Generous. After Cranach was ennobled in 1508, he used the winged snake with a ring in its mouth, which featured on his coat of arms, also as a signature for his paintings. He was described as the richest man in Wittenberg, and became its mayor in 1537. Cranach had a large studio where his sons Hans and Lucas also worked, churning out paintings to designs by their father. His *Virgin and child with bunch of grapes* (illustration p. 44) shows Cranach's ideal image of the Virgin: a high, round forehead and a charming, doll-like face.

His contemporary, Anthonie Mor van Dashorst (Antonio Moro) was also employed in the highest circles, in this case the court of the Habsburgs. In 1550, he was commissioned by Maria of Hungary to travel to Portugal, via Spain, and paint a portrait of the royal family. In 1554, Emperor Charles V asked him to go to England to paint a portrait of his prospective daughter-in-law, Mary Tudor. Philip II appointed Moro as his court artist. The Mauritshuis collection contains the *Portrait of Steven van Herwijck* (illustration p. 46), a Utrecht medallion engraver and gold- and silversmith, painted in 1564.

Adriaen Key, a Flemish artist who was influenced by Moro, painted the *Portrait of William the Silent, Prince of Orange* (illustration p. 47), believed to be based on an earlier prototype. A rather less stiff portrait is that of Cornelis Schellinger, church warden of the Oude Kerk in Amsterdam, by Pieter Pietersz (illustration p. 46). A caption refers to the assassination of William of Orange: 'Was shot this Year in Delft, which grieved many people. An[n]o 1584'. The seventeenth-century Dutch portrait artists found employment mainly among the relatively affluent middle classes: merchants, statesmen, men of science, church officials, militiamen and many who remain nameless.

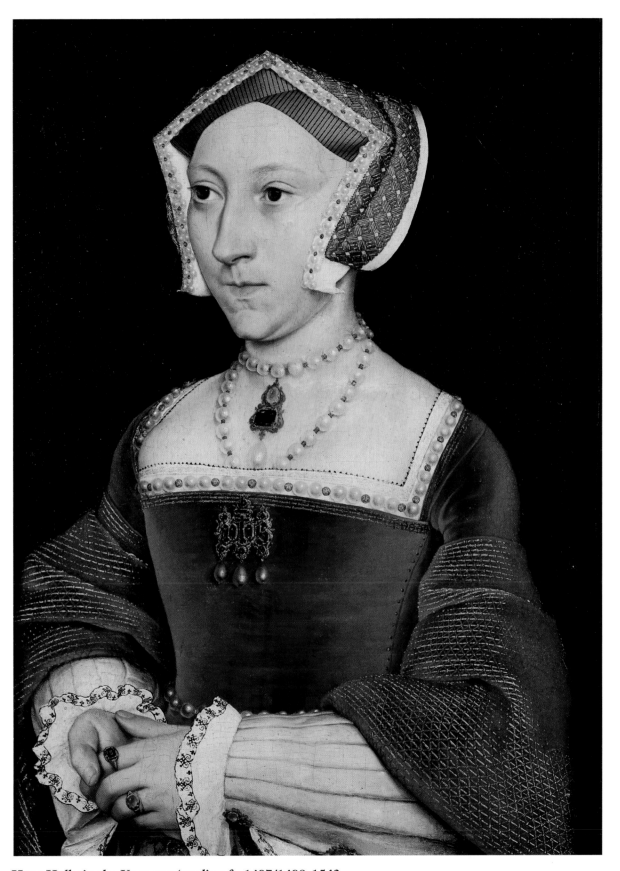

Hans Holbein the Younger (studio of), 1497/1498-1543
Portrait of Jane Seymour (1513-1537), Queen of England, third wife of Henry VIII, c. 1536/1537
Panel, 26.3 x 18.7 cm
Inv. no. 278

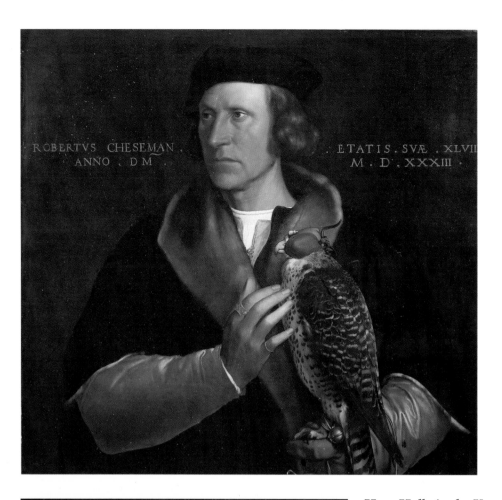

**Hans Holbein the Younger,
1497/1498-1543**
Portrait of Robert Cheseman (1485-1547),
1533
Panel, 59 x 62.5 cm
Inv. no. 276

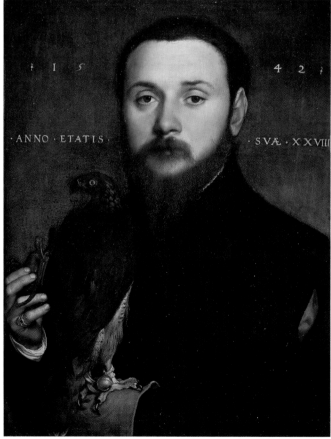

**Hans Holbein the Younger,
1497/1498-1543**
Portrait of a falconer aged 28, 1542
Panel, 25 x 19 cm
Inv. no. 277

**Hans Holbein the Younger (ascribed to),
1497/1498-1543**
Portrait of a young woman, c. 1517
Panel, 45 x 34 cm
Inv. no. 275

Michiel Sittow, probably 1469-1525
Portrait of a man, c. 1510/1515
Panel, 34 x 24 cm
Inv. no. 832

Lucas Cranach the Younger, 1515-1586
Portrait of a man with a red beard, 1548
Panel, 64 x 48 cm
Inv. no. 890

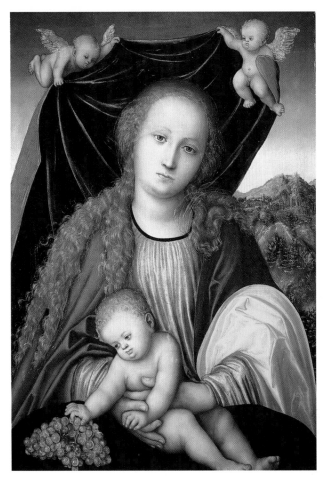

Lucas Cranach the Elder, 1472-1553
Virgin and child with bunch of grapes, c. 1520
Panel, 62.7 x 42 cm
Inv. no. 917

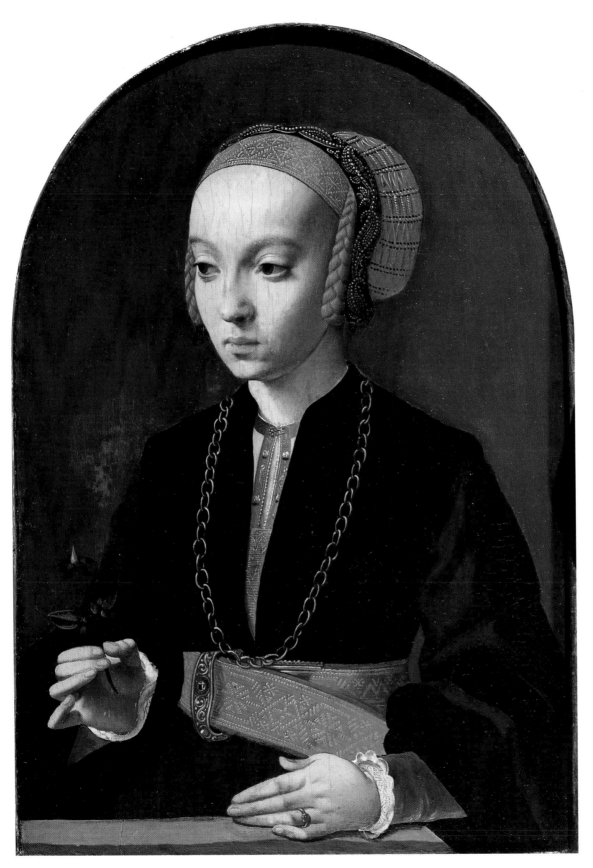

Bartholomeus Bruyn the Elder, 1493-1555
Portrait of a young woman, c. 1539/1540
Panel, 34.5 x 24 cm (painted surface 31.5 x 21.5 cm)
Inv. no. 889

Hans Bol, 1534-1593
Imaginary landscape with John the Evangelist on Patmos, 1564
Canvas, 47 x 82 cm
Inv. no. 1043

Anthonie Mor, 1516/1519-1575
Portrait of Steven van Herwijck (c. 1529-1570),
1564
Panel, 118.5 x 90 cm
Inv. no. 117

Pieter Pietersz, c. 1543-1603
Portrait of Cornelis Cornelisz Schellinger
(1551-1635), 1584
Panel, 68 x 51 cm
Inv. no. 4

Jan Sanders van Hemessen, c. 1500-1556/1557
Allegory on conjugal harmony, c. 1554
Panel, 159 x 189 cm
Inv. no. 1067

Adriaen Thomasz Key, c. 1544-after 1589
Portrait of William the Silent, Prince of Orange
(1533-1584), c. 1580/1584
Panel, 48 x 34 cm
Inv. no. 225

Jan Brueghel, Ambrosius Bosschaert and their generation

T he changing political and social situation in the late sixteenth-century Low Countries meant that artists received fewer commissions from the church, the court and the nobility. This period saw the rise of many specialist areas of painting more suitable for those of more modest means: still lifes, landscapes and scenes of daily life.

The art world in the southern Low Countries around 1600 was dominated by the Brueghel family, who worked in Antwerp and have rightly been described as a dynasty of painters. The Brueghels formed the connecting link between the technical refinement of the Flemish primitives and the rich imagination of Rubens' generation. Their greatest successes were their genre pieces and landscapes, and Jan Brueghel the Elder was the great proponent of the still life with flowers.

Joachim Beuckelaer's monumental painting, the *Kitchen scene with Christ in Emmaus* (illustration p. 50) shows that some areas of art grew up because biblical themes were becoming less dominant. This is a very worldly depiction of baskets of fruit and vegetables, meat and poultry, pewter mugs and earthenware jugs, bread and a wide variety of eating utensils. Christ and the men of Emmaus are very small figures visible through a semicircular gate in the background on the right-hand side, as a kind of admonition against worldly excess. After 1600, landscapes with biblical figures were largely replaced by more everyday scenes such as the gypsies telling fortunes in Abraham Govaert's landscape (illustration p. 51).

The northern Low Countries became a republic and left the Spanish empire in 1579. More so than in the south, Dutch painters gradually moved away from religious themes in favour of scenes from everyday life. Apart from history paintings, less elevated subjects were chosen: the genre painting and the landscape were probably the most typically Dutch products of the Golden Age. The painter and art theorist Carel van Mander foresaw somewhat sadly that many artists would start to specialise in portraits and other genres because they were more profitable or simply to feed their families, when history paintings should have been given preference. Van Mander believed portraits were 'a by-road of the Arts' [in translation]. If these standards had applied, however, gifted painters of still lifes such as Jan Brueghel the Elder (illustration p. 53), Jacob de Gheyn II (illustration p. 52) and Balthasar van der Ast (illustration p. 51) would have been very one-sided.

With the spread of humanism in the sixteenth century, mythological scenes also became more popular in the visual arts. Ovid's *Metamorphoses*, describing the legends of the ancient gods, was read as avidly as the Old and New Testaments had once been. In 1604, Carel van Mander published his *Schilder-Boeck* (Book of Painters) which was regarded as the artists' bible. To this he added an explanation of the *Metamorphoses* which, according to the title page, was for the benefit of artists, poets and art-lovers and anyone who sought to gain knowledge from it. The stories of the gods were portrayed in scenes which entertained but could also provide grounds for reflection. Joachim Wtewael's painting from 1601, *Venus and Mars surprised by Vulcan* (illustration p. 55) could have been intended as a warning against adultery.

Although the Brueghels worked in Antwerp, they provided an inspiration to artists in other cities. Not far from Antwerp, in Middelburg, Ambrosius Bosschaert followed in the footsteps of Jan Brueghel the Elder as a painter of still lifes with flowers. In his *Vase with flowers* (illustration p. 49), the nibbled leaves are a reminder of the transience of existence. 'The flower is the mirror of life: it blossoms but is blown away in the wind.'

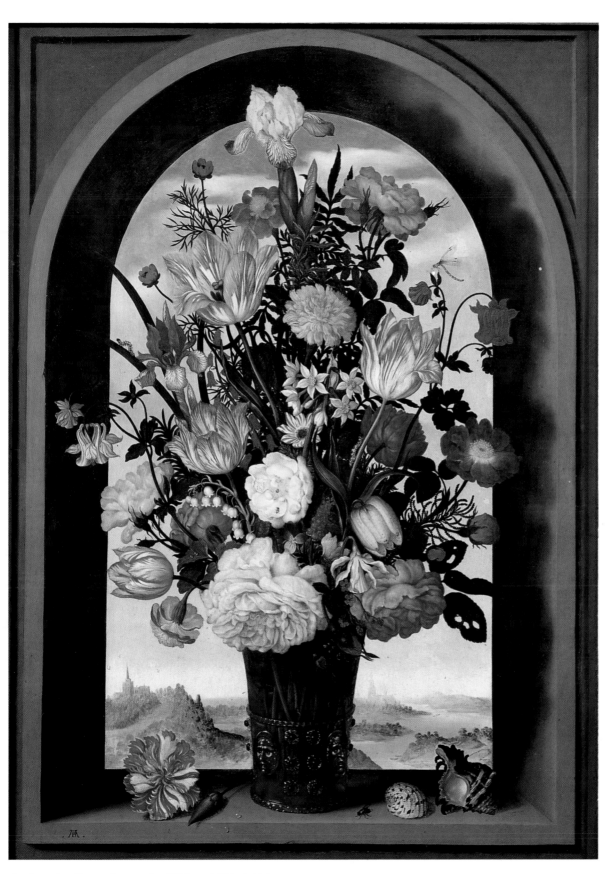

Ambrosius Bosschaert the Elder, 1573-1621
Vase with flowers, c. 1618/1619
Panel, 64 x 46 cm
Inv. no. 679

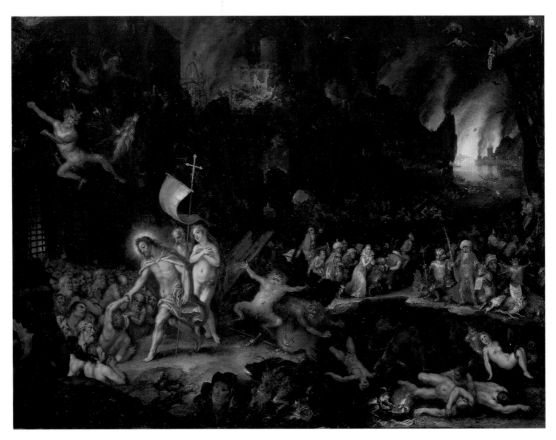

Jan Brueghel the Elder, 1568-1625 and Hans Rottenhammer, 1564-1624
The Descent, 1597
Copper, 26.2 x 35.4 cm
Inv. no. 285

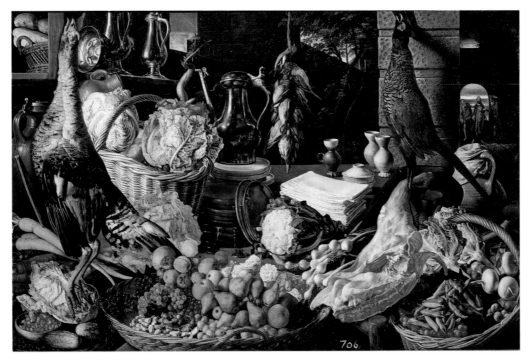

Joachim Beuckelaer, c. 1530-1573
Kitchen scene with Christ in Emmaus, c. 1566
Panel, 110 x 169 cm
Inv. no. 965

Abraham Govaerts, 1589-1626
Woodland landscape with gipsy women, 1612
Panel, 62.5 x 101 cm
Inv. no. 45

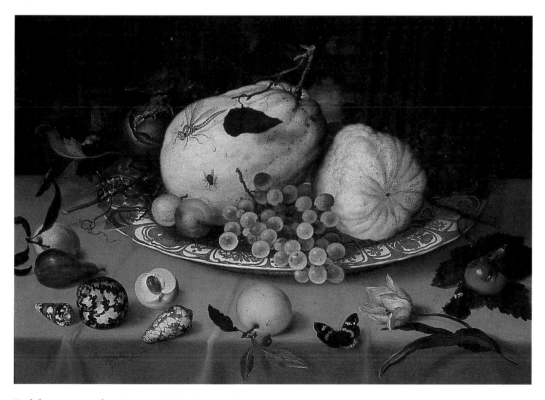

Balthasar van der Ast, 1593/1594-1657
Still life with fruit and shellfish, 1620
Panel, 46 x 64.5 cm
Inv. no. 1066

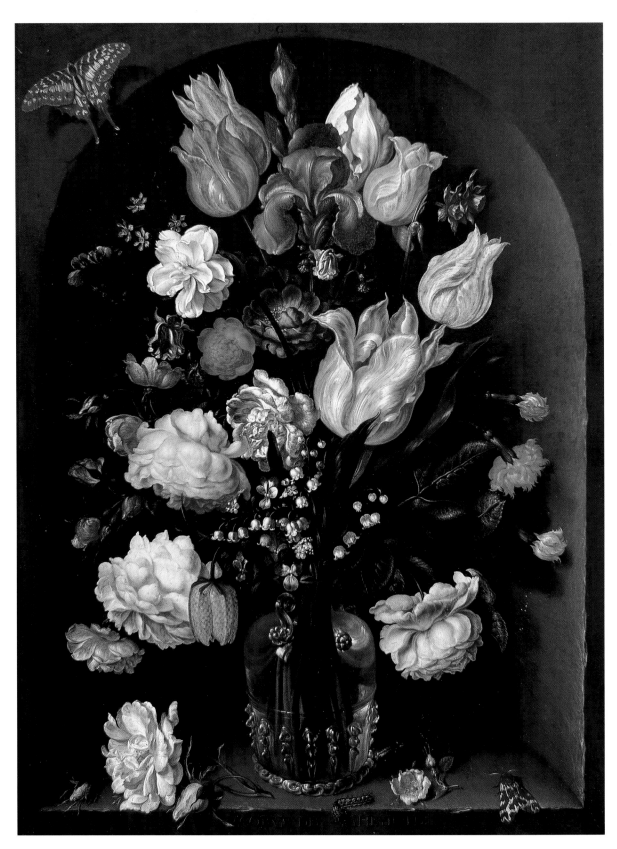

Jacob de Gheyn II, 1565-1629
Glass with flowers, 1612
Copper, 58 x 44 cm
Inv. no. 1077

Jan Brueghel the Elder, 1568-1625
Vase with flowers, c. 1610/1615
Panel, 42 x 34.5 cm
Inv. no. 1072

Frans Francken the Younger, 1581-1642, and studio,
Paul Vredeman de Vries, 1567-before 1636, and an unknown miniaturist
Ball at a Brussels court, c. 1610
Panel, 68.6 x 113.3 cm
Inv. no. 244

Abraham Bloemaert, 1564-1651
Feast of the gods, 1598
Canvas, 31.1 x 41.8 cm
Inv. no. 1046

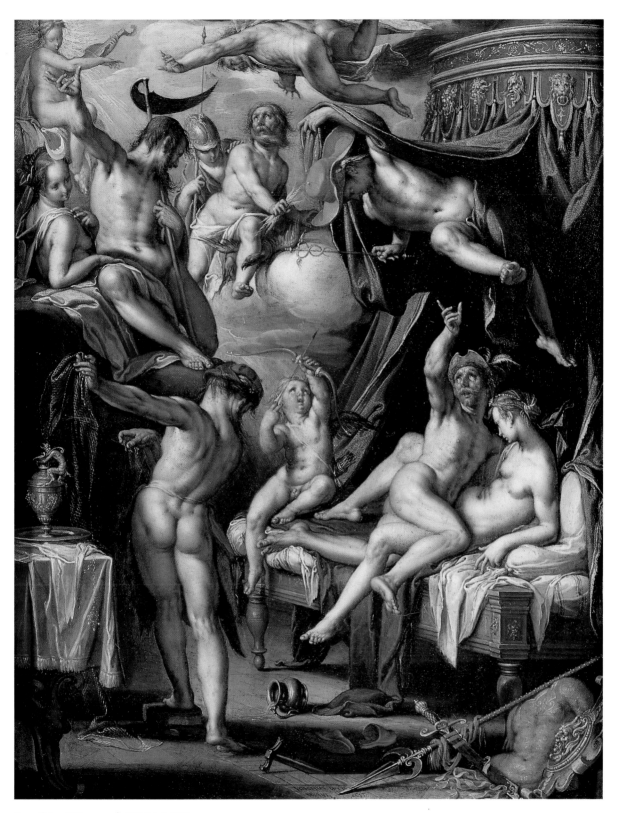

Joachim Wtewael, 1566-1638
Venus and Mars surprised by Vulcan, 1601
Copper, 20.8 x 15.7 cm
Inv. no. 223

Rubens and his circle

Soon after Peter Paul Rubens returned to Antwerp in 1608, after an eight-year stay in Italy he took over the leading role of Jan Brueghel the Elder. He became the most successful Flemish painter of the seventeenth century, and his work was soon in collections throughout western Europe. Rubens was a humanist; it has been said that painting was the least of his many talents. The 'prince of painters' had many patrons among the European royal courts, the clergy and the rich citizens in the southern Low Countries.

The world of Rubens and his patrons is very well documented in Willem van Haecht's *Apelles painting Campaspe* (illustration p. 63), a 'gallery painting' dating from around 1630. This depicts a scene from classical history, in which Alexander the Great commissioned his court artist Apelles to paint a portrait of Campaspe, his favourite concubine. When Alexander realised that Apelles was in love with her, he presented her to the famous painter as a gift.

Van Haecht administered the collection of Rubens' patron Cornelis van der Geest, a wealthy Antwerp merchant and great lover of art, described by Rubens in 1638 as 'the best of men and the oldest of friends, my constant protector since my youth'. Van der Geest's collection included well-known works by masters such as Pieter and Jan Brueghel the Elder, Anthony van Dyck, Adam Elsheimer, Jan van Eyck, Quinten Massys and of course Rubens. Their paintings can be seen in this 'studio of Apelles'. In 1637, Willem van Haecht bequeathed *Apelles painting Campaspe* to Van der Geest. In 1765, the panel was acquired for a huge sum from the King of Poland's collection by William V. The Gallery Prince William V on the Buitenhof in The Hague is one of the few art galleries that still uses the same method of hanging paintings as in Van Haecht's day, in rows one above the other (illustration p. 25).

In the centre foreground of this gallery painting is *Diana and her nymphs*, painted by Rubens together with his friend Jan Brueghel the Elder. Another work painted by the two artists together was *The garden of Eden with the fall of man* (illustration p. 58). The inscriptions at the bottom read: 'PETRI PAVLI RVBENS FIGR' and 'IBRVEGHEL FEC', meaning that Rubens painted the figures of Adam and Eve and Brueghel the rest of the painting. It was not unusual for two artists to work together in this way, each contributing his own speciality. This painting has always been described in superlatives. Apart from its extraordinary technical virtuosity, it is also unusually rich in symbolism: the monkey behind Adam is a symbol of evil and sin, and is taking a bite out of an apple, presaging what Adam himself is about to do.

Brueghel, Rubens and Van der Geest belonged to the élite of Antwerp, consisting of magistrates, scholars and artists: humanists, rhetoricians and lovers of art. This circle also included Peeter Stevens, the city almoner of Antwerp. Anthony van Dyck produced a portrait of him in 1627 (illustration p. 61), followed a year later by one of his bride Anna Wake, to mark their marriage (illustration p. 60). Anna was the daughter of an English merchant who was a companion of Rubens and his business representative in England. The Golden Age of Antwerp painting around 1625 is particularly well represented in the Mauritshuis, with works by Rubens, Brueghel, Van Dyck and Jordaens.

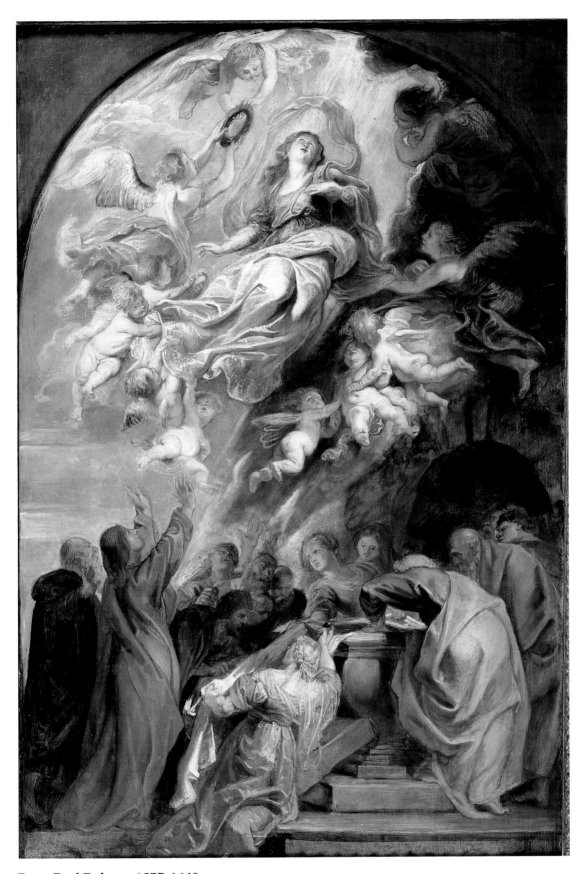

Peter Paul Rubens, 1577-1640
'Modello' for the assumption of the Virgin, c. 1622/1625
Panel, 87.8 x 59.1 cm
Inv. no. 926

**Jan Brueghel the Elder, 1568-1625 and
Peter Paul Rubens, 1577-1640**
The garden of Eden with the fall of man, c. 1615
Panel, 74.3 x 114.7 cm
Inv. no. 253

Peter Paul Rubens, 1577-1640
Portrait of Michael Ophovius (1570-1637), c. 1618
Canvas, 111.5 x 82.5 cm
Inv. no. 252

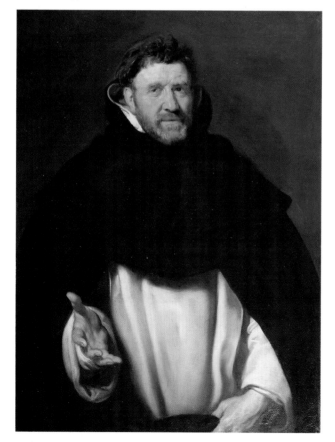

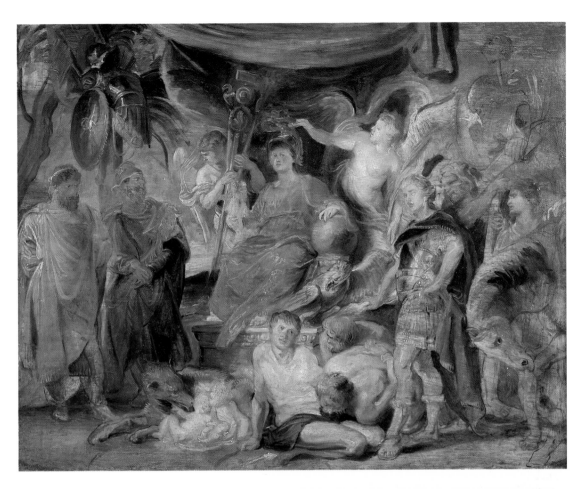

Peter Paul Rubens, 1577-1640
*The triumph of Rome: the young emperor
Constantine honours Rome*, c. 1622
Panel, 54 x 69 cm
Inv. no. 837

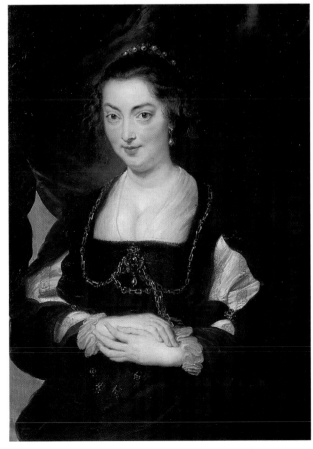

Peter Paul Rubens, 1577-1640
Portrait of Isabella Brant (?) (1591-1626), c. 1625
Panel, 97 x 67.8 cm
Inv. no. 250

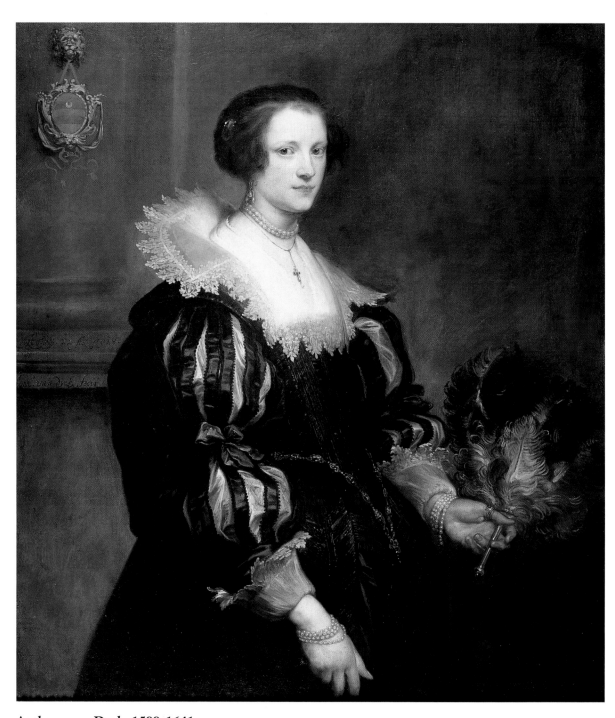

Anthony van Dyck, 1599-1641
Portrait of Anna Wake (1606-?), 1628
Canvas, 112.5 x 99.5 cm
Inv. no. 240

Anthony van Dyck, 1599-1641
Portrait of Peeter Stevens (1590-1668),
1627
Canvas, 112.5 x 99.5 cm
Inv. no. 239

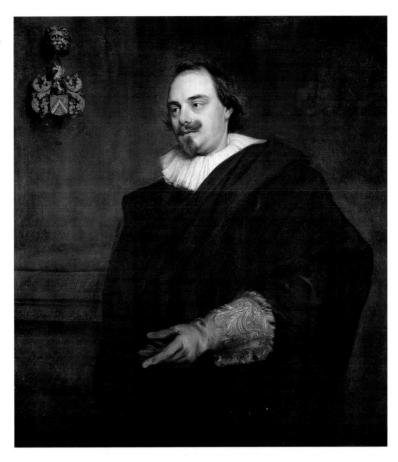

Anthony van Dyck, 1599-1641
Portrait of Quintijn Simons (1592-?),
c. 1634
Canvas, 98 x 84 cm
Inv. no. 242

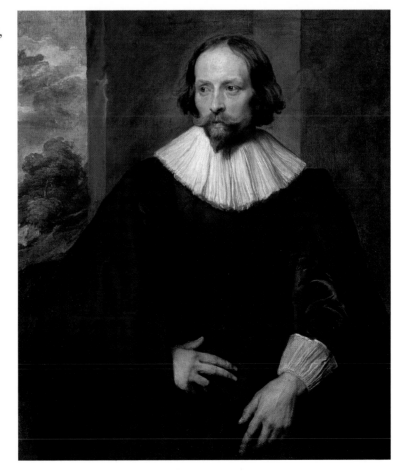

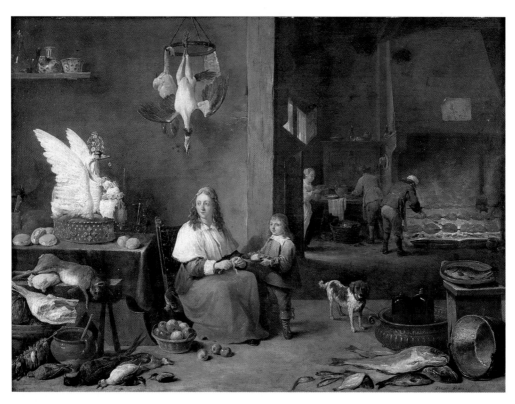

David Teniers the Younger, 1610-1690
Kitchen interior, 1644
Copper, 57 x 77.8 cm
Inv. no. 260

Adriaen Brouwer, 1605/1606-1638
The smoker, or The smell, c. 1630/1635
Panel, 29.4 x 21.3 cm
Inv. no. 962

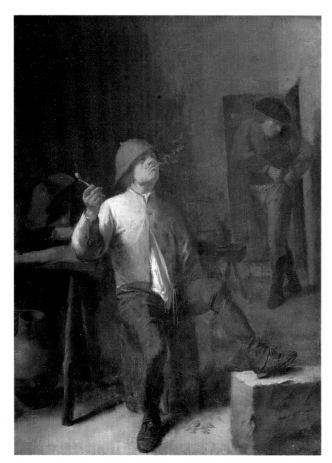

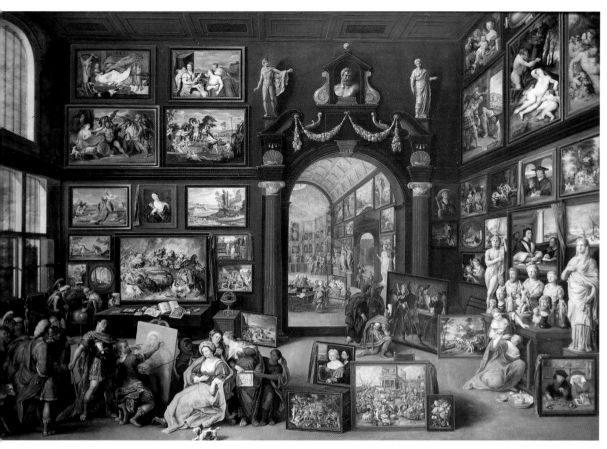

Willem van Haecht, 1593-1637
Apelles painting Campaspe, c. 1630
Panel, 104.9 x 148.7 cm
Inv. no. 266

Jacob Jordaens, 1593-1678
The adoration of the shepherds, c. 1617
Panel, 125 x 95.7 cm
Inv. no. 937

Vermeer and the Dutch realists

Realism has often been described as one of the most striking features of seventeenth-century Dutch painting. This is certainly the case, but only if realism is not simply understood as a highly accurate representation of reality. For a number of Delft artists, realism meant closely reproducing the way light fell on figures and objects. One good illustration of this is Johannes Vermeer's *View of Delft* (illustration p. 67). At first sight, the painting is an accurate representation of the town of Delft, but study of old maps has shown that Vermeer moved some of the buildings to create a better composition. The subtle depiction of light, partly obtained by using small dots of paint, is very convincing. Vermeer painted his *Girl with a pearl earring* (illustration p. 65) in about 1660. The earring worn by this 'Dutch Mona Lisa' is a wonderful illusion, created using two simple dots of white paint over a slight hint of paint on a huge pearl whose outlines are barely visible. But from a distance, this earring is just as 'real' as the broad yellow and blue stripes and dots of paint on the turban and garment. The fabric and cut are more suggested than depicted.

One of the jewels of the Mauritshuis collection is *The goldfinch*, painted in 1654 by another Delft artist, Carel Fabritius (illustration p. 71). It depicts a very ordinary subject - a bird on its food tray - but it has always been greatly admired for its surprisingly realistic effect, particularly if the picture is looked at from some distance away. This is an example of *trompe l'œil* (deception of the eye): surprising masterpieces such as this painting mark the peak of the Golden Age.

Painters have often tried to look at scenes from unusual viewpoints or to deceive the eye. The Delft painter Gerard Houckgeest did this by using an unexpected perspective in his church interiors. In *The tomb of William of Orange in Delft* (illustration p. 70), a large pillar in the middle foreground leads the eye towards this national monument. Likewise the Haarlem architectural painter Pieter Saenredam appears to have simply painted what he saw in *The Mariaplaats and Mariakerk in Utrecht* (illustration p. 66). But he deliberately set the church amid tranquil surroundings when in real life the bustle of the marketplace would have been constantly apparent.

Gerard ter Borch was one of the few leading masters to come from Overijssel. He painted more finely, with smaller brush strokes, but he too had a preference for simple subjects to demonstrate his subtle painting skills. One good example is *The louse hunt* (illustration p. 69). The careful painting technique, using layers of colour - the brick red of the dress, the blue of the child's pinafore and a somewhat hazy blue in the mother's velvet smock - has been described as a reflection of Ter Borch's cautious personality. But it is obviously invidious to draw parallels between a painter and his technique or subject. This is particularly the case if the artist depicts himself as a man visiting a prostitute, as Frans van Mieris the Elder did in his *Brothel scene* (illustration p. 73). The meaning of the scene is depicted using two small dogs mating: this may be somewhat unsubtle, but the painting technique itself is extremely fine, and people in the seventeenth century would have seen this painting as humorous. The depiction of the fabric of the serving-maid's dress is breathtaking, and we hardly notice that the soldier is tugging at her dress. Paintings such as these have been widely praised for their realism, but they usually involved a great deal of manipulation on the artist's part.

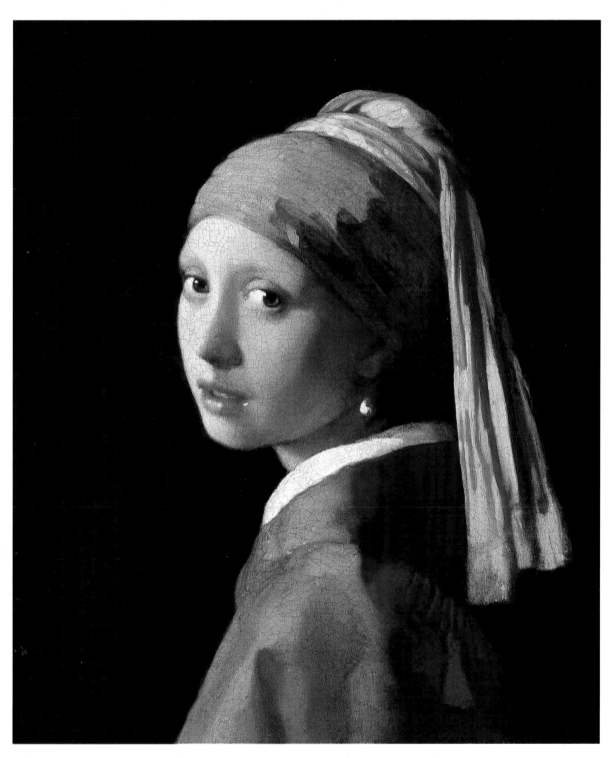

Johannes Vermeer, 1632-1675
Girl with a pearl earring, c. 1660
Canvas, 46.5 x 40 cm
Inv. no. 670

Pieter Saenredam, 1597-1665
The Mariaplaats and Mariakerk in Utrecht, 1659
Panel, 44 x 63 cm
Inv. no. 974

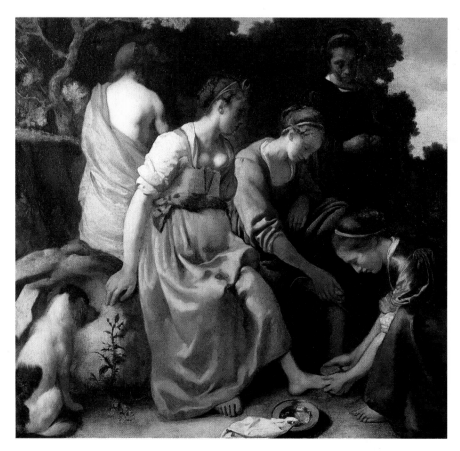

Johannes Vermeer, 1632-1675
Diana and her nymphs, c. 1655
Canvas, 97.8 x 106 cm
Inv. no. 406

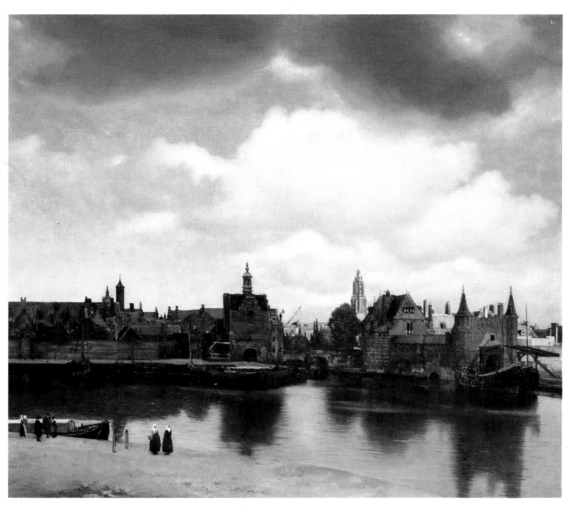

Johannes Vermeer, 1632-1675
View of Delft, c. 1660
Canvas, 98 x 117.5 cm
Inv. no. 92

**Pieter Saenredam,
1597-1665**
*The interior of the Cunerakerk
in Rhenen*, 1655
Panel, 50 x 68.8 cm
Inv. no. 888

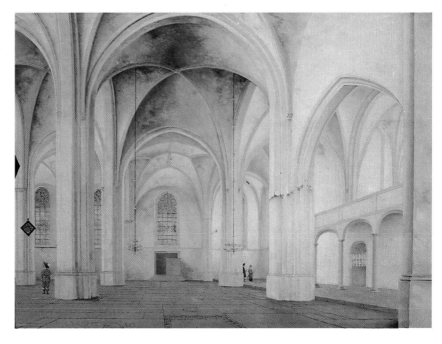

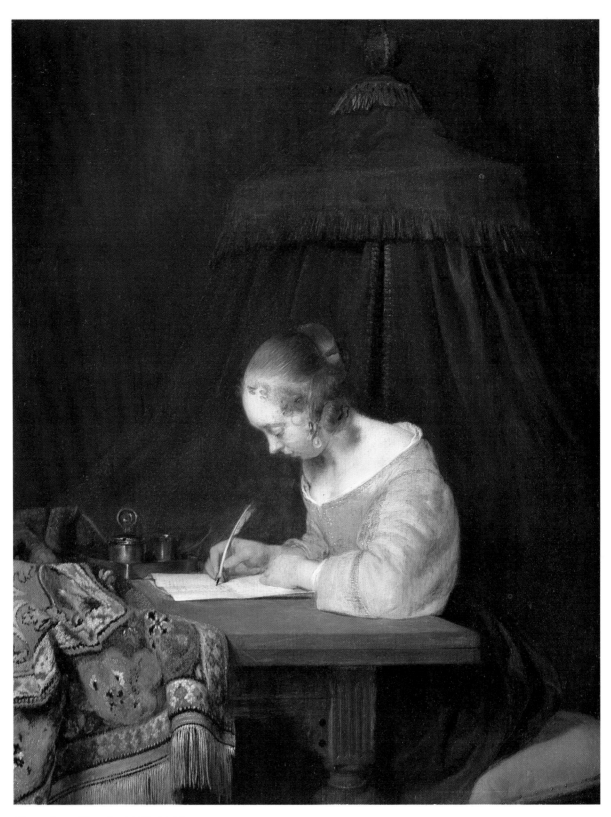

Gerard ter Borch, 1617-1681
Woman writting a letter, c. 1655
Panel, 39 x 29.5 cm
Inv. no. 797

Gerard ter Borch, 1617-1681
The louse hunt, c. 1652/1653
Panel, 33.5 x 29 cm
Inv. no. 744

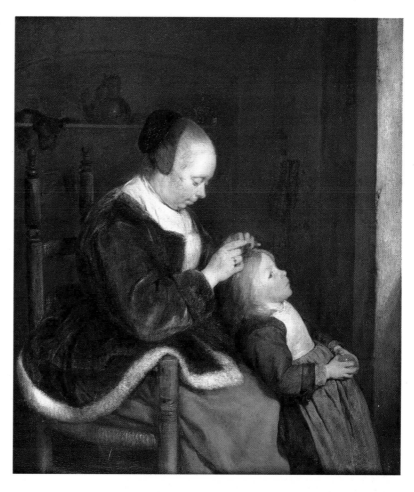

Gerard ter Borch, 1617-1681
Self-portrait, c. 1667/1670
Canvas, 61 x 42.5 cm
Inv. no. 177

Gerard Houckgeest, c. 1600-1661
The tomb of William of Orange in Delft, 1651
Panel, 56 x 38 cm
Inv. no. 58

Emanuel de Witte, 1615/1617-1691/1692
View of an imaginary church with monks, 1668
Canvas, 110 x 85 cm
Inv. no. 473

Gabriël Metsu, 1629-1667
Woman writing music,
c. 1662/1663
Panel, 57.5 x 43.5 cm
Inv. no. 94

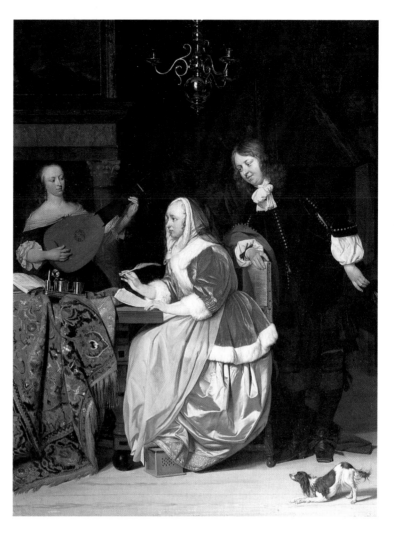

Carel Fabritius, 1622-1654
The goldfinch, 1654
Panel, 33.5 x 22.8 cm
Inv. no. 605

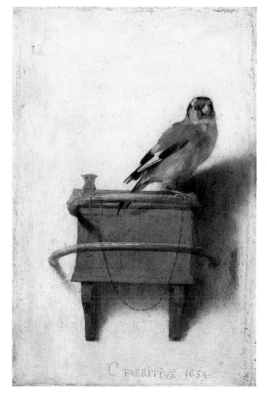

Frans van Mieris the Elder, 1635-1681
Boy blowing bubbles, 1663
Panel, 25.5 x 19 cm
Inv. no. 106

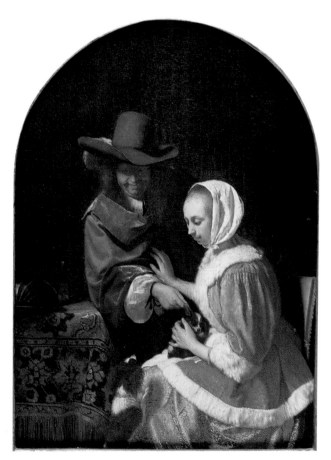

Frans van Mieris the Elder, 1635-1681
Teasing a puppy, 1660
Panel, 27.5 x 20 cm
Inv. no. 108

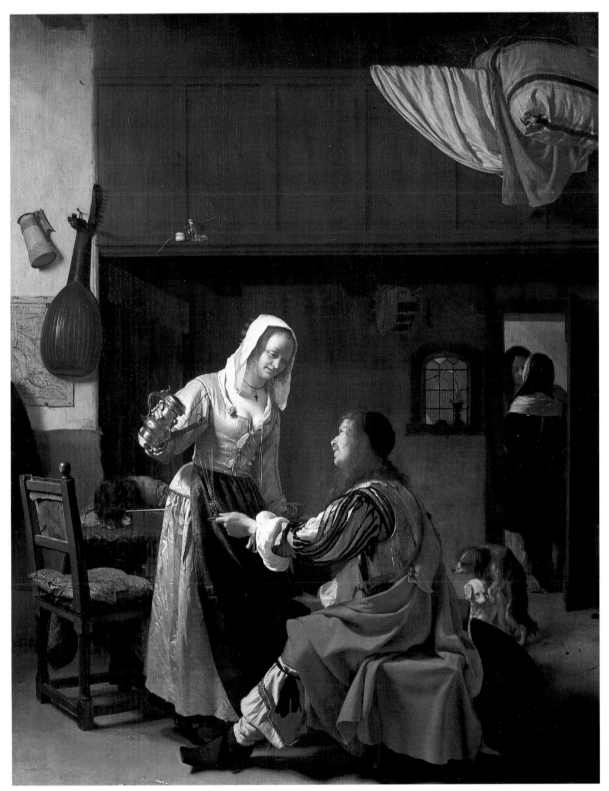

Frans van Mieris the Elder, 1635-1681
Brothel scene, c. 1658
Panel, 42.8 x 33.3 cm
Inv. no. 860

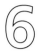

Frans Hals and Jan Steen

Apart from Rembrandt and Vermeer, Frans Hals and Jan Steen were among the most important artists of the Dutch Golden Age. Frans Hals was internationally renowned for the artistic virtuosity of his portraits, and Jan Steen for his humorous depictions of human behaviour. Dining militiamen, ordinary people laughing, drinking and making music: these were the main subjects of Frans Hals' paintings apart from portraits. Some believe that Hals himself must have been a cheerful man with personal experience of the low-life scenes he depicted. In the nineteenth century, a 'vrolijke Frans' (cheerful Frans) was a name given to a carefree person. Hals's relaxed style of painting was also seen as being the result of a dissolute lifestyle. But speculation of this kind is a distraction from his unique talent. Hals used a broad, flowing style which, according to reports of the time, was reserved to the greatest old masters such as Titian. Hals painted Jacob Olycan and Aletta Hanemans (illustrations p. 77) after their marriage in 1625 in a fine, detailed style, while his 1660 painting of a now anonymous resident of Haarlem is an example of the much looser style which he used towards the end of his career (illustration p. 76).

Jan Steen is best known for his scenes from everyday life, and the Mauritshuis contains some superb examples of these. In Dutch, the phrase a 'Jan Steen household' means a chaotically untidy one, and here again, people have sometimes jumped to conclusions about the artist's own life based on his subject matter. Steen's painting *The life of man* (illustration p. 81) embodies a hidden truth about life amid the apparent disorder. 'Life is a stage; we play our part and receive our reward,' wrote Vondel, the greatest poet of the Netherlands. Here, Jan Steen is illustrating his vision of human existence, and inciting us to virtue by showing the worst side of life. The boy in the attic, under a raised curtain and with a skull beside him, blows soap bubbles into the room. The message is this: beware, for human life is a bubble which could burst at any time. In *'The way you hear it is the way you sing it'* (illustration p. 83) the home truth from the title (if you set a bad example, people will follow you) is even written on the paper from which the old woman is reading.

People in the seventeenth century did not always take such a subtle view of their fellow-humans. Judith Leyster depicts a grinning man trying to seduce a young girl with money (illustration p. 80). Jan Miense Molenaer (who was married to Judith Leyster) used popular figures to illustrate the five senses in scenes which would have been easily recognisable. Smell is depicted by the stink of a baby's bottom, and touch by a woman hitting a man with her shoe (illustrations pp. 78-79).

Isack van Ostade specialized in pleasant everyday scenes set amid sunny landscapes (illustration p. 83). His gentle view of life influenced his older brother Adriaen van Ostade, whose interiors full of fighting, drinking peasants were gradually replaced by almost idyllic scenes from rural life (illustrations pp. 84, 85).

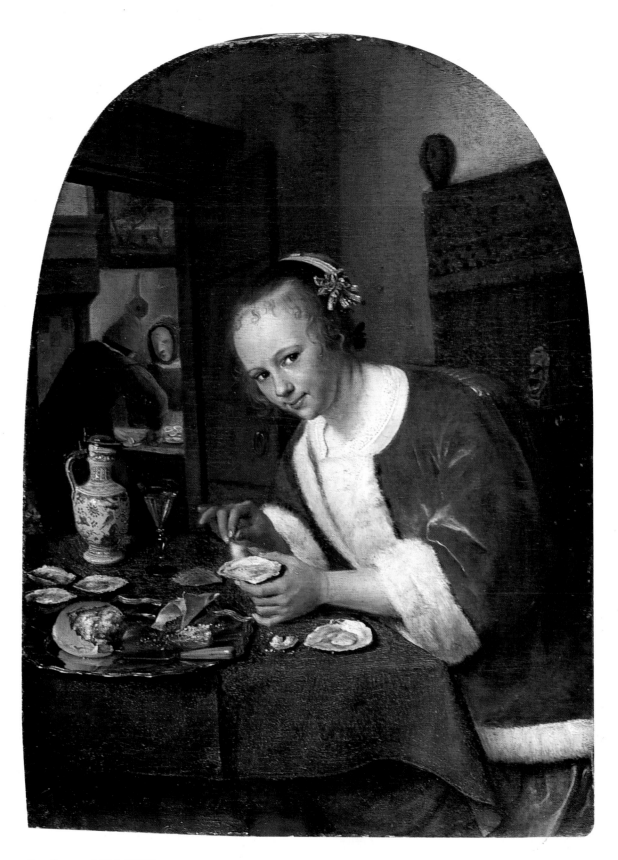

Jan Steen, 1626-1679
Girl eating oysters, c. 1658/1660
Panel, 20.5 x 14.5 cm
Inv. no. 818

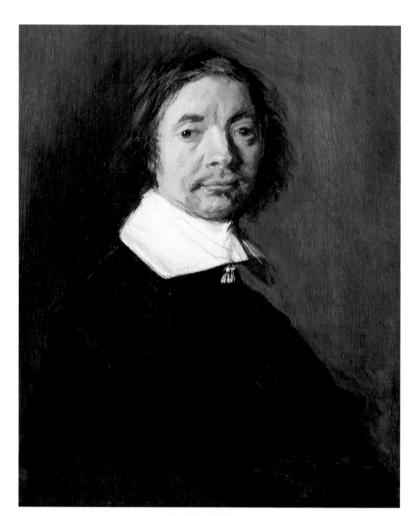

Frans Hals, 1581/1585-1666
Portrait of a man, c. 1660
Panel, 31.6 x 25.5 cm
Inv. no. 928

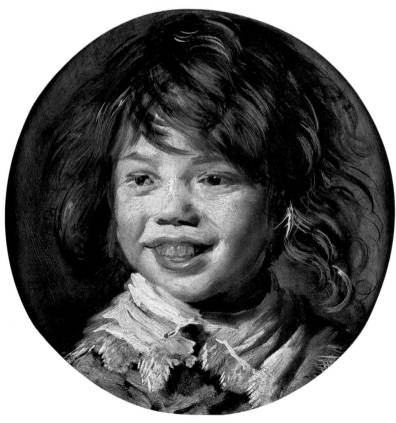

Frans Hals, 1581/1585-1666
Laughing boy, c. 1625
Panel, diameter 29.5 cm
Inv. no. 1032

Frans Hals, 1581/1585-1666
Portrait of Jacob Pietersz Olycan (1596-1638),
1625
Canvas, 124.6 x 97.3 cm
Inv. no. 459

Frans Hals, 1581/1585-1666
Portrait of Aletta Hanemans (1606-1653),
1625
Canvas, 124.2 x 98.2 cm
Inv. no. 460

1 **Jan Miense Molenaer, c. 1610-1668**
 Touch, 1637
 Panel, 19.5 x 24.2 cm
 Inv. no. 572

2 **Jan Miense Molenaer, c. 1610-1668**
 Sight, 1637
 Panel, 19.6 x 23.9 cm
 Inv. no. 573

3 **Jan Miense Molenaer, c. 1610-1668**
 Hearing, 1637
 Panel, 19.4 x 24.2 cm
 Inv. no. 574

4 **Jan Miense Molenaer, c. 1610-1668**
 Smell, 1637
 Panel, 19.5 x 24.3 cm
 Inv. no. 575

5 **Jan Miense Molenaer, c. 1610-1668**
 Taste, 1637
 Panel, 19.6 x 24.1 cm
 Inv. no. 576

3

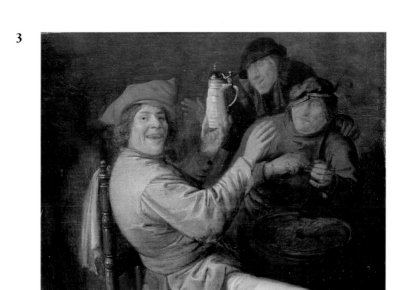

4

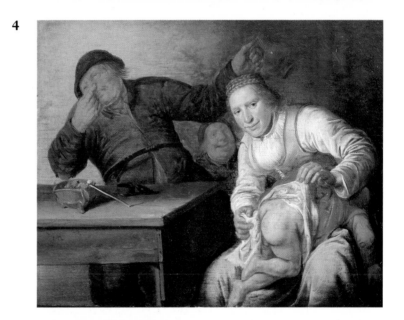

5

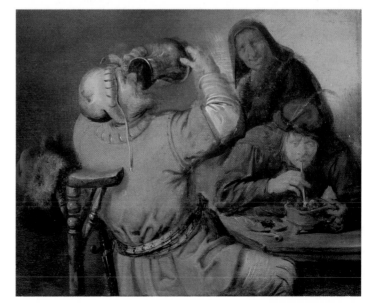

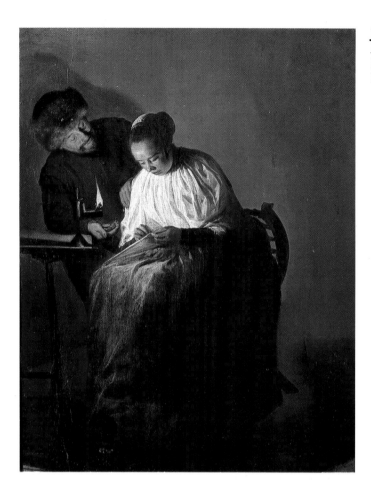

Judith Leyster, 1609-1660
Man offering a woman money, 1631
Panel, 30.9 x 24.2 cm
Inv. no. 564

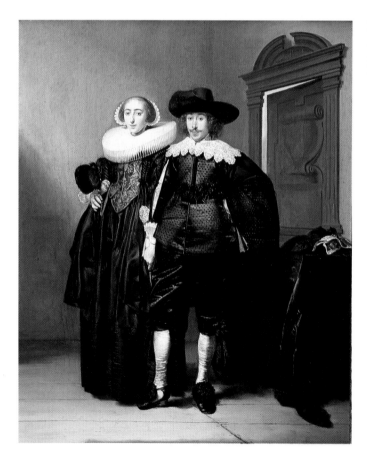

Pieter Codde, 1599-1670
Portrait of a betrothed couple, 1634
Panel, 43 x 35 cm
Inv. no. 857

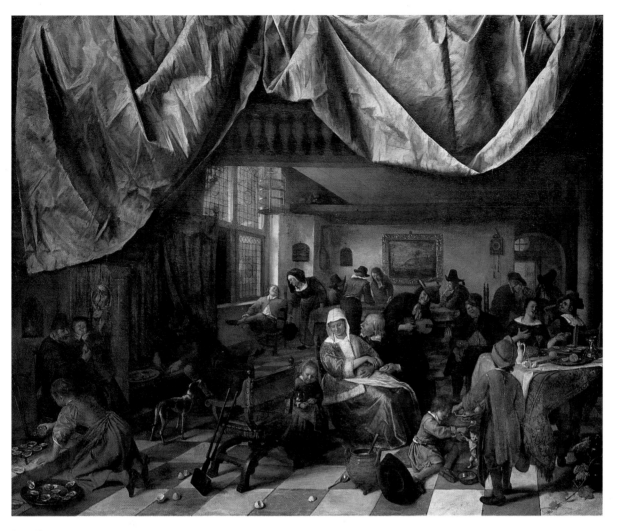

Jan Steen, 1626-1679
The life of man, c. 1674
Canvas, 68.2 x 82 cm
Inv. no. 170

Jan Steen, 1626-1679
Portrait of Jacoba Maria van Wassenaer or of Bernardina Margriet van Raesfeld, 1660
Canvas, 107.4 x 81.4 cm
Inv. no. 166

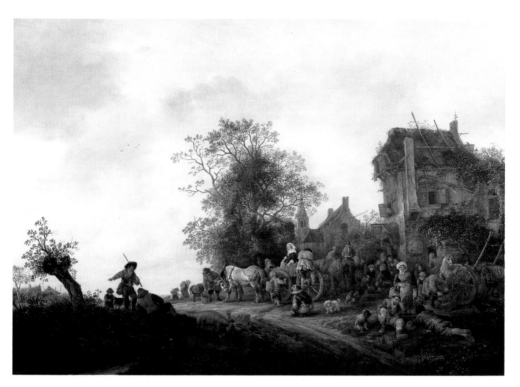

Isack van Ostade, 1621-1649
Travellers outside an inn, 1646
Panel, 75 x 109 cm
Inv. no. 789

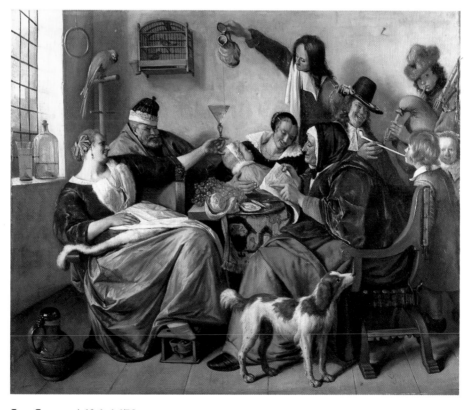

Jan Steen, 1626-1679
'The way you hear it is the way you sing it', c. 1663
Canvas, 134 x 163 cm
Inv. no. 742

Adriaen van Ostade, 1610-1685
The violin player, 1673
Panel, 45 x 42 cm
Inv. no. 129

Cornelis Troost, 1697-1750
Allegory of the war with France in 1747, 1747
Canvas, 82 x 102 cm
Inv. no. 1034

Adriaen van Ostade, 1610-1685
Peasants in an inn, 1662
Panel, 47.5 x 39 cm
Inv. no. 128

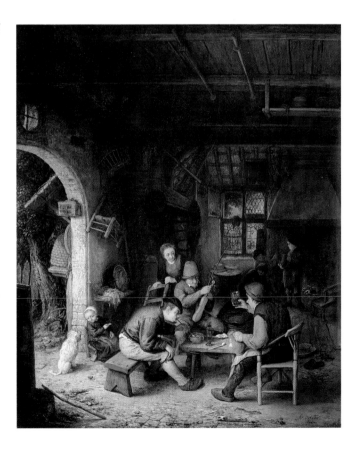

 # Caravaggists, Italianates and Classicists

In the seventeenth century, many artists from the northern Low Countries either worked abroad or were influenced by foreign artists. These painters were out of favour with the public for a long period during the nineteenth and first half of the twentieth centuries because their style and subject matter were not typically 'Dutch'. Mannerists, Caravaggists, Italianates and Classicists eschewed the polders, woods and dunes which were seen as a typical feature of the Dutch Golden Age.

The Caravaggists were mainly artists from Utrecht who visited Italy and worked in the style of Caravaggio. These painters enjoyed a resurgence in popularity after World War II. Several generations were taught by Abraham Bloemaert and then gradually moved to Italy. One of these painters, Hendrick ter Brugghen, returned from the south in 1614, brimming with new ideas (illustration p. 87), and was followed in 1620 by Gerard van Honthorst. Because Bloemaert lived to such a great age, his work was influenced by a number of major stylistic changes, from Mannerism (illustration p. 54) via Caravaggism to a toned-down version of Classicism (illustration p. 88). The realistic drama and strong interplay of light and shade which characterised Caravaggio's work also had a great influence outside Utrecht, particularly on Rembrandt and his pupils.

While Caravaggists preferred to paint biblical and secular stories with human figures that fill the picture, the Italianates depicted sun-drenched southern landscapes, often peopled with biblical or mythological figures or shepherds and nymphs. Examples of the latter include Breenbergh's *Landscape with nymphs of the hunt (and Diana?)* (illustration p. 90) and Dirck van der Lisse's *Sleeping nymph of the hunt* (illustration p. 91). Both artists greatly admired and were influenced by their teacher, Cornelis van Poelenburch, who specialized in Italian landscapes with ancient ruins and gods (illustration p. 90). Jan Both's *Italian landscape* (illustration p. 89) is another typically Italianate work. This was painted in the period after 1641 when the artist returned from Italy and resumed work in Utrecht. Here, his main aim was to create a southern atmosphere: the figures are almost an afterthought. *The calling of Saint Matthew* (illustration p. 92) is an example of a collaboration between two Italianates: Claes Berchem and Jan Baptist Weenix. Berchem probably mainly painted the figures in this biblical scene, while Weenix painted the Roman-style architecture and the animals.

While the Italianate landscape painters are enjoying renewed popularity, the Classicists are still awaiting a revival. Classicism was an intellectual movement which took its subjects and forms from Classical antiquity: two good examples are Caesar van Everdingen's *Trompe-l'œil with a bust of Venus* (illustration p. 94) and Jacob van Campen's *Mercury, Argus and Io* (illustration p. 95). Van Campen was first and foremost an architect, best known as the builder of the Mauritshuis (illustrations pp. 12-15) and the palace on the Dam in Amsterdam which are textbook examples of Dutch Classicism. Constantijn Huygens made use of his knowledge of Classical architecture between 1635 and 1637, when he built a house opposite the Mauritshuis. It was also during these years that Van Campen painted the *Portrait of Constantijn Huygens and Suzanna van Baerle* (illustration p. 95).

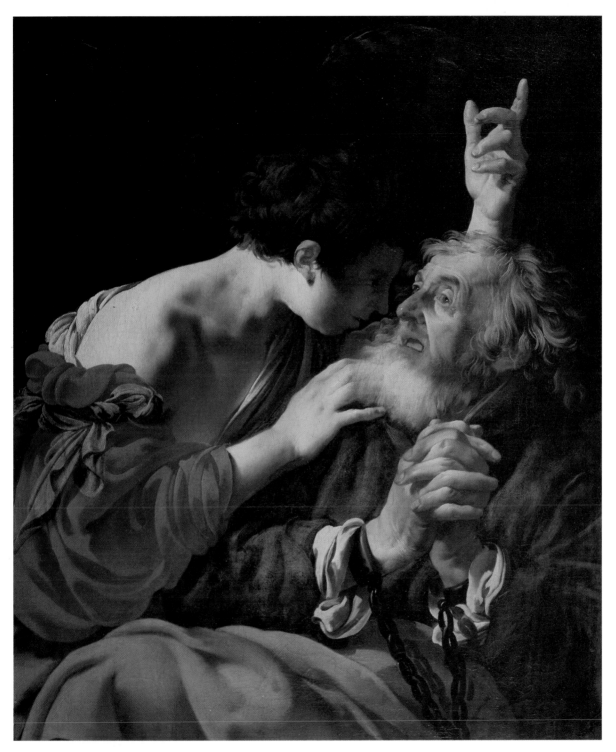

Hendrick ter Brugghen, 1588-1629
The liberation of Saint Peter, 1624
Canvas, 104.5 x 86.5 cm
Inv. no. 966

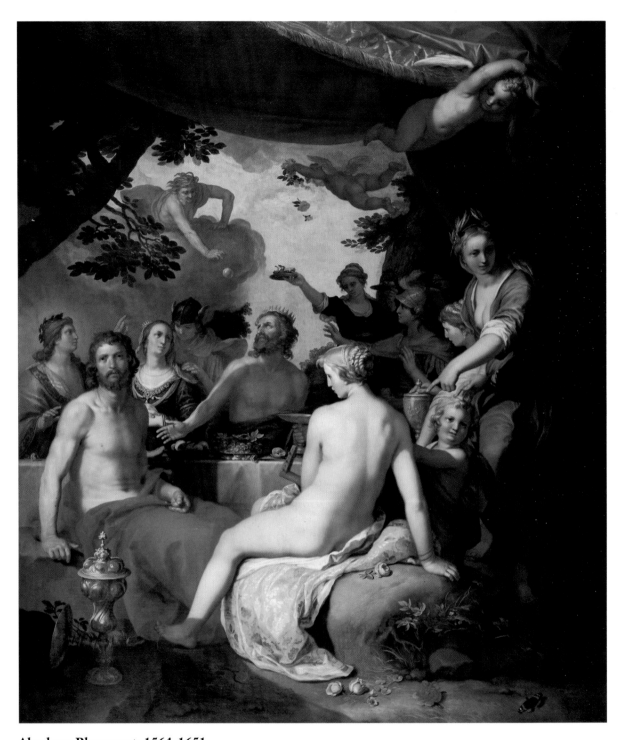

Abraham Bloemaert, 1564-1651
The feast of the gods at the wedding of Peleus and Thetis, 1638
Canvas, 193.7 x 164.5 cm
Inv. no. 17

Jan Both, c. 1615-1652
Italian landscape, c. 1641/1652
Canvas, 108.2 x 125.8 cm
Inv. no. 20

Jacob Backer, 1608-1651
Self-portrait as shepherd, c. 1635/1640
Panel, 51 x 39.5 cm
Inv. no. 1057

Bartholomeus Breenbergh, 1598-1657
Landscape with nymphs of the hunt (and Diana?), 1647
Panel, 37.8 x 50 cm
Inv. no. 1098

Cornelis van Poelenburch, 1594/1595-1667
Gathering of gods in the clouds, c. 1630
Copper, 38 x 49 cm
Inv. no. 1065

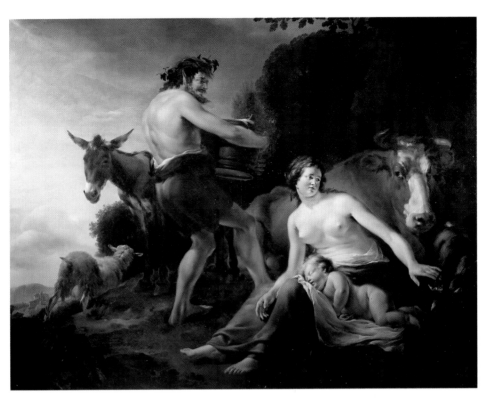

Claes Berchem, 1620-1683
The infancy of Zeus, 1648
Canvas, 202 x 262 cm
Inv. no. 11

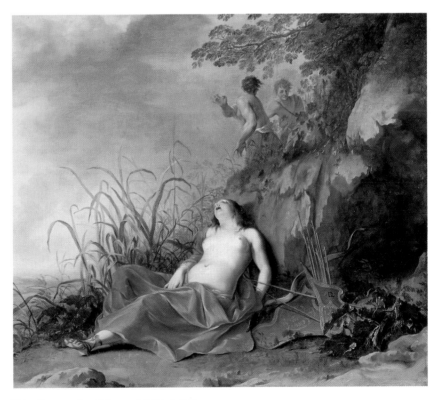

Dirck van der Lisse, 1607-1669
Sleeping nymph of the hunt, after 1642
Panel, 44 x 51.8 cm
Inv. no. 1093

Claes Berchem, 1620-1683 and
Jan Baptist Weenix, 1621-1660/1661
The calling of Saint Matthew, c. 1657
Panel, 98.2 x 120.8 cm
Inv. no. 1058

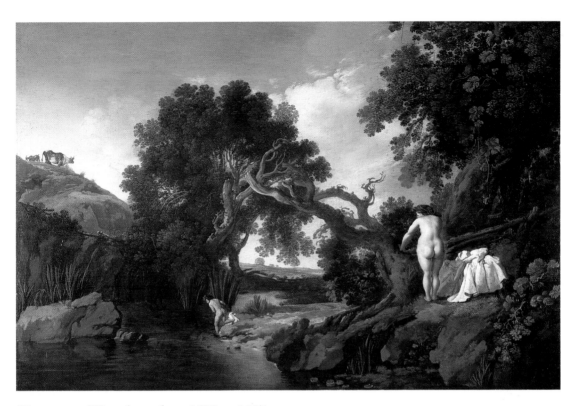

Moyses van Wttenbrouck, c. 1590-c. 1647
Woodland pond with Salmacis and Hermaphroditus, 1627 (?)
Panel, 43 x 66 cm
Inv. no. 1097

Jan Baptist Weenix, 1621-1660/1661
Italian landscape with inn and ancient ruins, 1658
Panel, 68.2 x 87.2 cm
Inv. no. 901

Caesar van Everdingen, c. 1617-1678
Diogenes looking for an honest man, 1652
Canvas on panel, 76 x 103.5 cm
Inv. no. 39

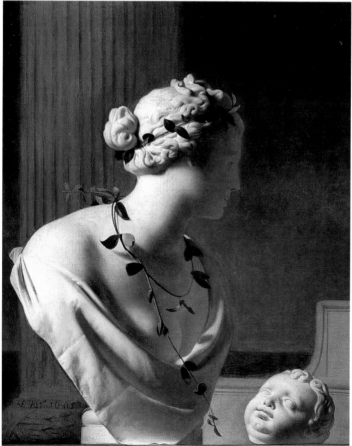

Caesar van Everdingen, c. 1617-1678
Trompe-l'oeil with a bust of Venus,
1665
Canvas, 74 x 60.8 cm
Inv. no. 1088

Jacob van Campen, 1595-1657
Mercury, Argus and Io,
c. 1630/1640
Canvas, 204 x 193 cm
Inv. no. 1062

Jacob van Campen, 1595-1657
Portrait of Constantijn Huygens
(1596-1687) and Suzanna van Baerle
(1599-1637), c. 1635
Canvas, 95 x 78.5 cm
Inv. no. 1089

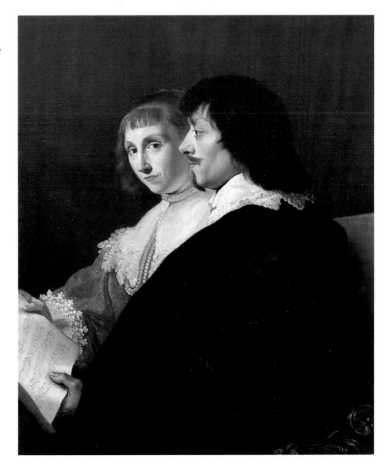

Rembrandt and his school

There are few painters from the Dutch Golden Age who can be said to have had a school, as Rubens did in Flanders. Rembrandt certainly harboured such ambitions, but failed to obtain support from affluent patrons such as the church and the court. He painted for Stadholder Frederick Henry, but literally and figuratively on a small scale. When the governors of Amsterdam had the chance to commission Rembrandt to produce the monumental paintings in the town hall, the idea was dropped through concern over whether his work was appropriate. The militiamen of the Kloveniersdoelen were more enlightened when they commissioned their group portrait, which became world-famous as the *'The Night Watch'* (Rijksmuseum, Amsterdam). Another milestone in the art of the group portrait was *The anatomy lesson of Dr Nicolaes Tulp* (illustration p. 99). This painting was acquired by the Mauritshuis in 1828 at King William I's order. Thanks to the House of Orange, the Mauritshuis already contained some works by Rembrandt. The finest work from his Leiden period, *Simeon's song of praise* (illustration p. 98) was purchased by Prince William IV in 1733. Prince William V bought a number of Rembrandts in 1768, including the early *Self-portrait with a halberd* (illustration p. 97) and *Suzanna* (illustration p. 99). The *Homer* (illustration p. 100) bequeathed by Abraham Bredius, the former director of the Mauritshuis, is a monumental late history painting. But the crowning glory of the Mauritshuis Rembrandt collection was acquired in 1947: the *Self-portrait in 1669* (illustration p. 101), painted in the last year of the artist's life.

Artists closely associated with Rembrandt are also well represented in the Mauritshuis. One is his teacher Pieter Lastman, who was convinced that the true artist must primarily be a historical painter; he is represented by the biblical painting *David giving the letter to Uriah* (illustration p. 102). Rembrandt's pupils all began by making history paintings, and Gerbrand van den Eeckhout continued to do so for the whole of his career (illustration p. 104). Ferdinand Bol also had ambitions in this direction, and was given an opportunity to fulfil them in the decoration of Amsterdam's city hall, but he was essentially a somewhat stiff society portrait painter (illustration p. 106). Arent de Gelder, Rembrandt's last pupil, still used the broad style of Rembrandt's later works until long after his teacher's death, with a virtuoso use of paint and warmth of colour (illustration p. 105). Gerard Dou (illustration p. 103) was a pupil from Rembrandt's Leiden period. He developed his own version of the meticulous style of Rembrandt's early works such as *Simeon's song of praise*, and created his own 'school' of Leiden *fijnschilders*. Samuel van Hoogstraten painted mainly perspective pieces (illustration p. 107). Hercules Segers was a remarkable painter of dream-like, exotic scenes, regarded even in his own time as a prime example of an underrated talent. Rembrandt appears to have been very fond of Segers' work, since he owned at least seven of his landscapes (illustration p. 105).

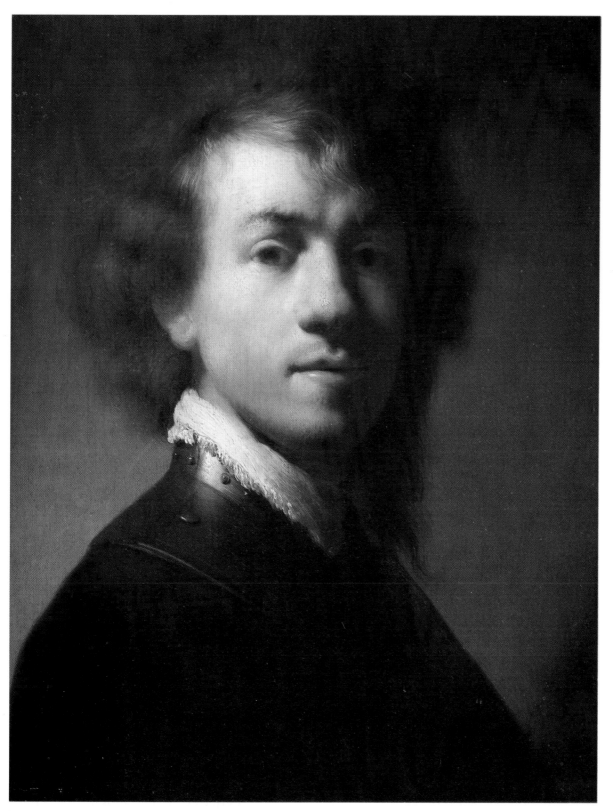

Rembrandt Harmensz van Rijn, 1606-1669
Self-portrait with a halberd, c. 1629
Panel, 37.7 x 28.9 cm
Inv. no. 148

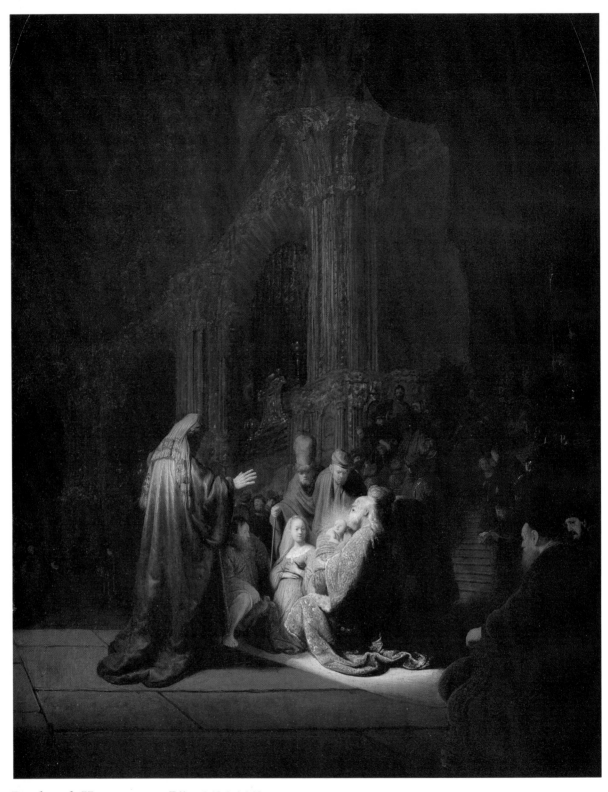

Rembrandt Harmensz van Rijn, 1606-1669
Simeon's song of praise, 1631
Panel, 60.9 x 47.9 cm
Inv. no. 145

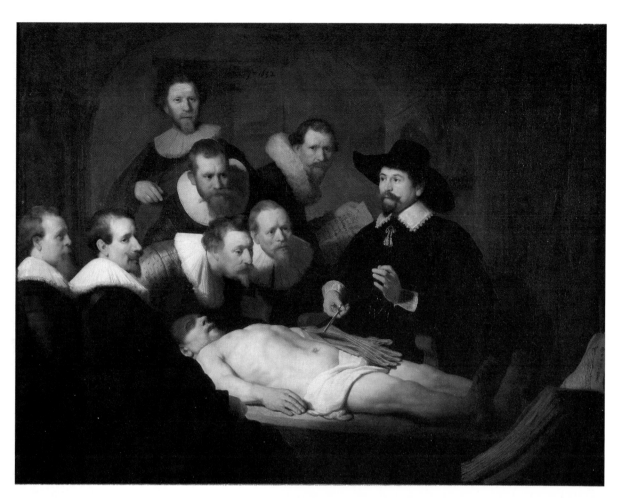

**Rembrandt Harmensz van Rijn,
1606-1669**
The anatomy lesson of Dr Nicolaes Tulp, 1632
Canvas, 169.5 x 216 cm
Inv. no. 146

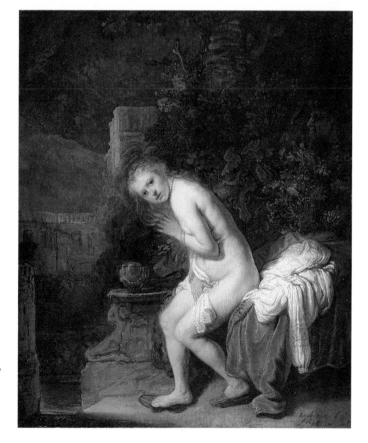

**Rembrandt Harmensz van Rijn,
1606-1669**
Suzanna, 1636 (?)
Panel, 47.4 x 38.6 cm
Inv. no. 147

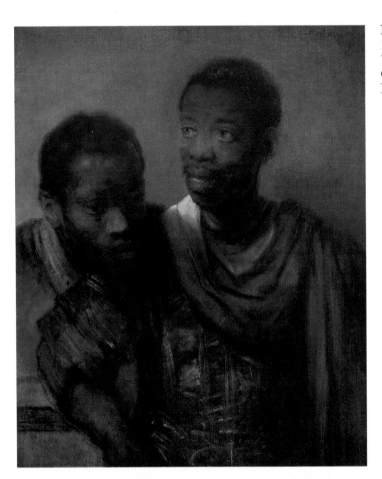

Rembrandt Harmensz van Rijn, 1606-1669
The two negroes, 1661
Canvas, 77.5 x 64.4 cm
Inv. no. 685

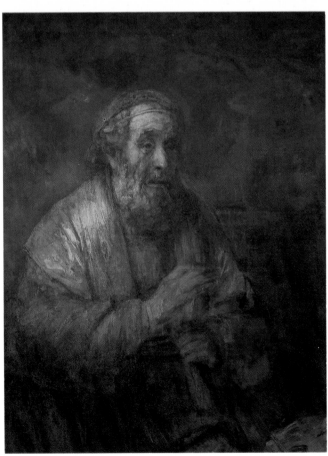

Rembrandt Harmensz van Rijn, 1606-1669
Homer, 1663
Canvas, 107 x 82 cm
Inv. no. 584

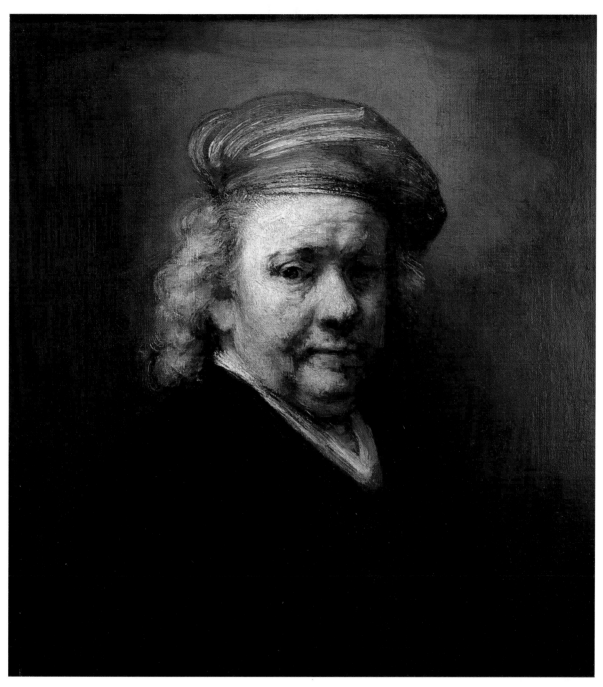

Rembrandt Harmensz van Rijn, 1606-1669
Self-portrait in 1669
Canvas, 63.5 x 57.8 cm
Inv. no. 840

Pieter Lastman, 1583-1633
David giving the letter to Uriah, 1619
Panel, 42.5 x 63 xm
Inv. no. 1074

Thomas de Keyser, 1596/1597-1667
Portrait of Loef Vredericx (1590-1668) as a standard-bearer, 1626
Panel, 92.5 x 69 cm
Inv. no. 806

Gerard Dou, 1613-1675
The young mother, 1658
Panel, 73.5 x 55.5 cm
Inv. no. 32

**Gerbrand van den Eeckhout,
1621-1674**
Isaac and Rebecca, 1665
Canvas, 128.2 x 169.8 cm
Inv. no. 1084

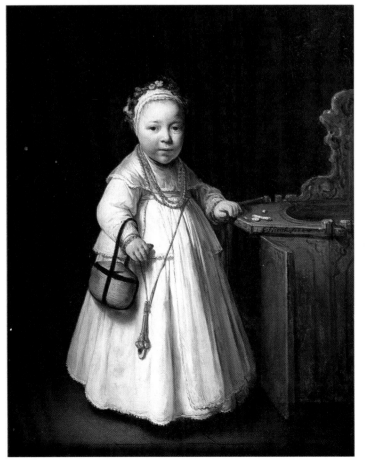

Govaert Flinck, 1615-1660
Girl by a child's chair, 1640
Canvas, 114.2 x 87.3 cm
Inv. no. 676

Hercules Segers, 1589/1590-in or after 1633
River landscape, c. 1620
Panel, 22.5 x 53 cm
Inv. no. 1033

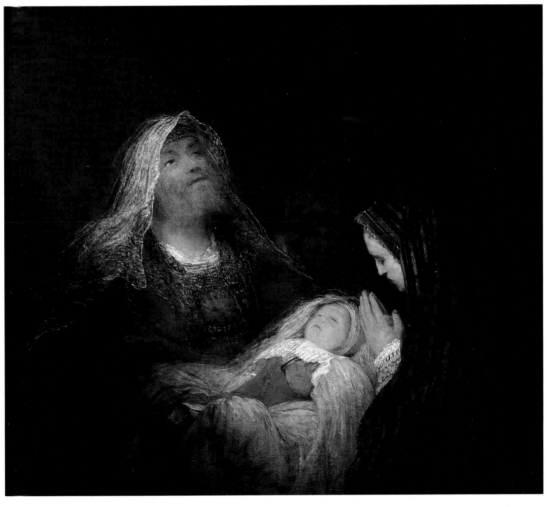

Arent de Gelder, 1645-1727
Simeon's song of praise, c. 1700
Canvas, 94.5 x 107.5 cm
Inv. no. 1047

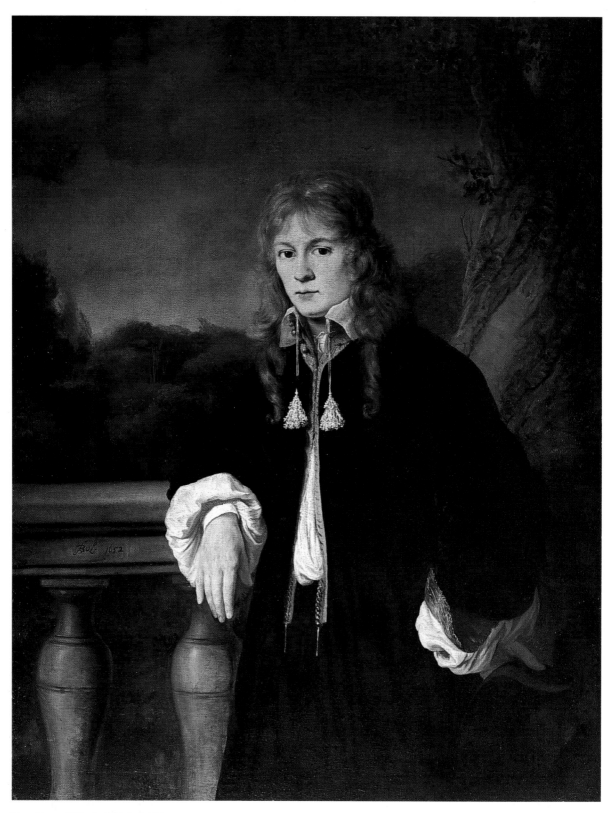

Ferdinand Bol, 1616-1680
Portrait of Louis Trip junior (?), 1652
Canvas, 128 x 99 cm
Inv. no. 795

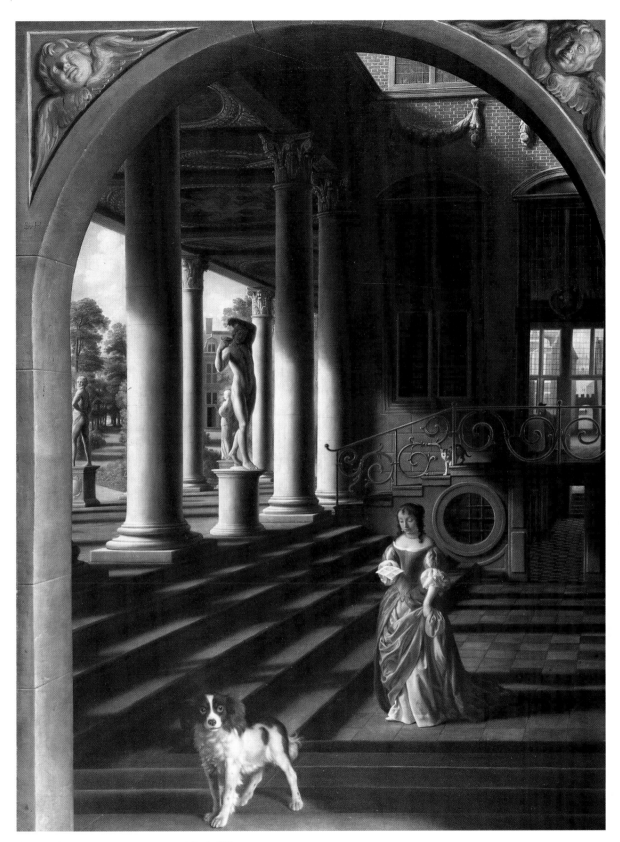

Samuel van Hoogstraten, 1627-1678
Girl with a letter, c. 1660/1665
Canvas, 214 x 179 cm
Inv. no. 66

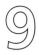 Van Beyeren and De Heem: masters of the still life

Specialist areas of painting such as portraits, landscapes and still lifes flourished during the Golden Age. All displayed a remarkable degree of diversity within the boundaries of their chosen genre, and still lifes were no exception. There were still lifes with flowers and vanitas-symbols, as well as hunting and ornamental still lifes, and 'banquets' or 'breakfasts'. One very fine example is the *Still life with earthenware jug and pipes* (illustration p. 112) by Pieter van Anraadt, a largely unknown portrait artist who produced this single great masterpiece. Contemporary viewers could have seen the painting as simply a depiction of two of life's little pleasures, or they might have seen it as a didactic piece with a hidden meaning. But they would undoubtedly have recognised the four elements: fire in the coal pan, air which is drawn through the pipe and tobacco, earth in the material of the earthenware jug and water from which the beer is made.

The transitory nature of material things is a very common message of still lifes. In the university town of Leiden, the *vanitas* still life became a genre in its own right, with dusty, learned books as an obvious feature. In 1628, Jan Davidsz de Heem painted an example of this genre: a *Still life with books* (illustration p. 110) in which the violin symbolizes the fleeting nature of music and the tattered books that of the arts and sciences. Two years later, Pieter Claesz painted his *Vanitas still life* (illustration p. 110), with an extinguished candle, a glass which has been tipped over, and an open watch, all reminding us of the inevitability of death. Sometimes, as in this painting, the *memento mori* was spelled out more explicitly in the form of a human bone and a skull. Willem Claesz Heda's 1629 painting (illustration p. 111) includes an open watch as a symbol of the passing of time in a scene depicting a modest breakfast.

In later still lifes, as in Heda's, the element of vanitas became less and less obvious. Willem van Aelst's *Still life with flowers and watch* (illustration p. 113) is primarily a feast for the eye, but here again the scene includes a watch, and the leaves of the roses are tattered and withered. In his *Hunting still life with dead partridges* (illustration p. 114) a single fly crawls across the spotless white wing of the dead bird. And Abraham van Beyeren's *Ornamental still life* (illustration p. 115) also includes the traditional references to temporality in the form of a clock and a glass lying on its side. But reflected in the glass of the goblet, we see the artist looking at us from behind his easel, which is highly significant: what could be more fleeting than a reflection in a mirror? Jan Davidsz de Heem's *Vase with flowers* from the early 1670s (illustration p. 109) includes a similar reflection in the vase. Here, the large number of moralistic references contained in earlier works is replaced by an inconspicuous detail: caterpillars have chewed holes in the leaves in the bottom left of the picture. But apart from these minutiae, this painting is a vivid display of colour in a sumptuous composition which reveals an innate sense of precision.

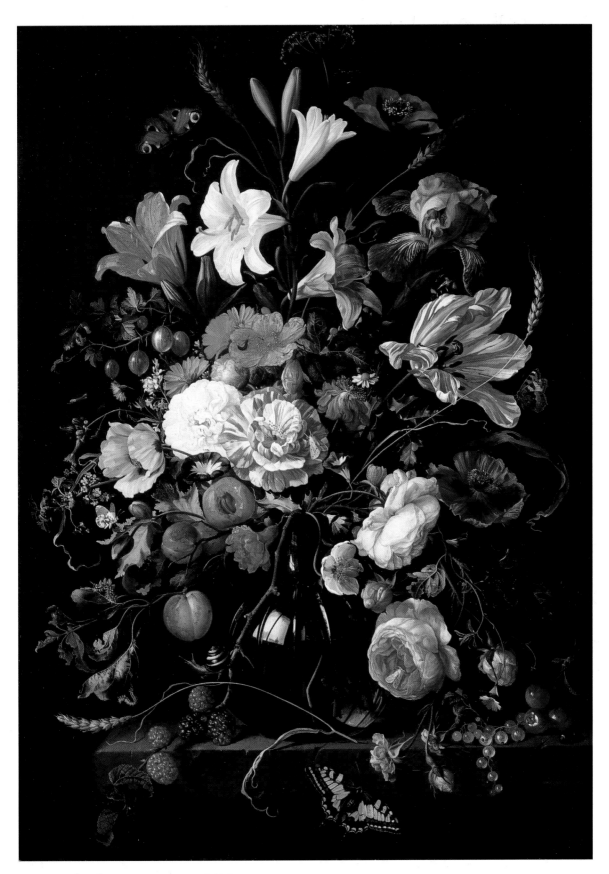

Jan Davidsz de Heem, 1606-c. 1684
Vase with flowers, c. 1670
Canvas, 74.2 x 52.6 cm
Inv. no. 1099

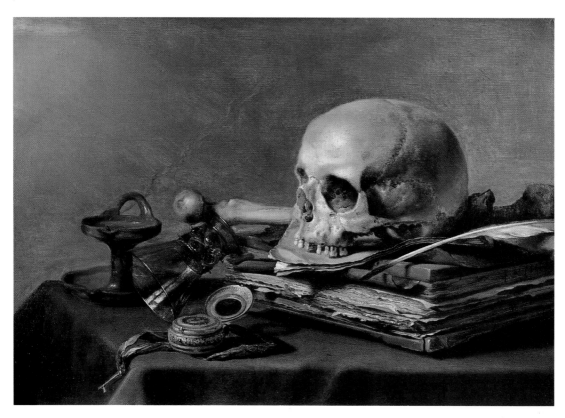

Pieter Claesz, c. 1597-1660
Vanitas still life, 1630
Panel, 39.5 x 56 cm
Inv. no. 943

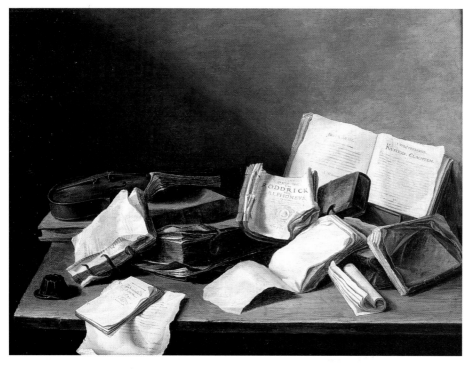

Jan Davidsz de Heem, 1606-c. 1684
Still life with books, 1628
Panel, 36.1 x 48.4 cm
Inv. no. 613

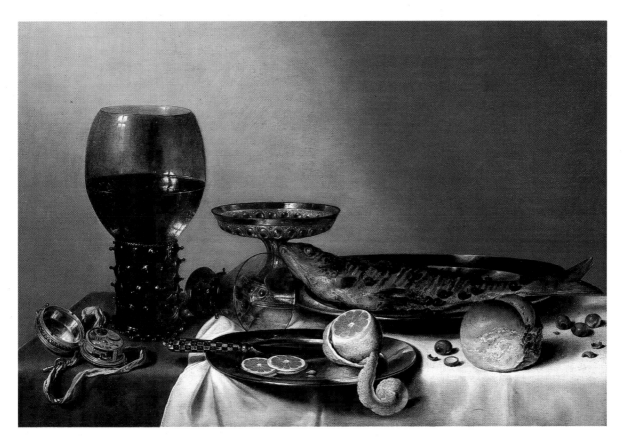

Willem Claesz Heda, 1594/1595–c. 1680
Still life with goblet, 1629
Panel, 46 x 69.2 cm
Inv. no. 596

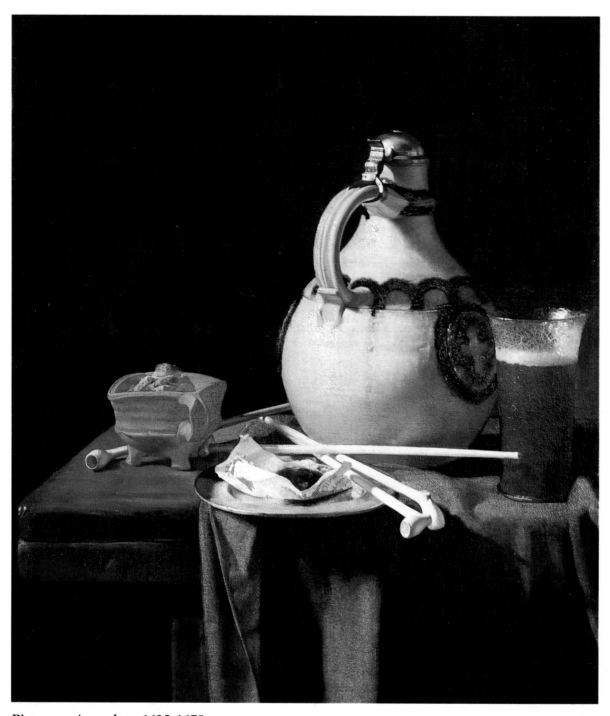

Pieter van Anraadt, c. 1635-1678
Still life with earthenware jug and pipes, 1658
Canvas, 67 x 59 cm
Inv. no. 1045

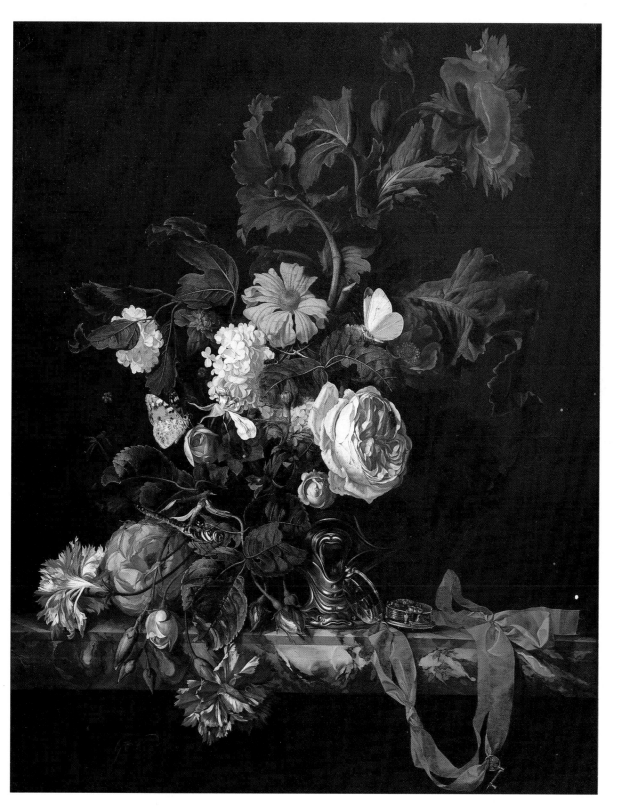

Willem van Aelst, 1627–c. 1683
Still life with flowers and watch, 1663
Canvas, 62.5 x 49 cm
Inv. no. 2

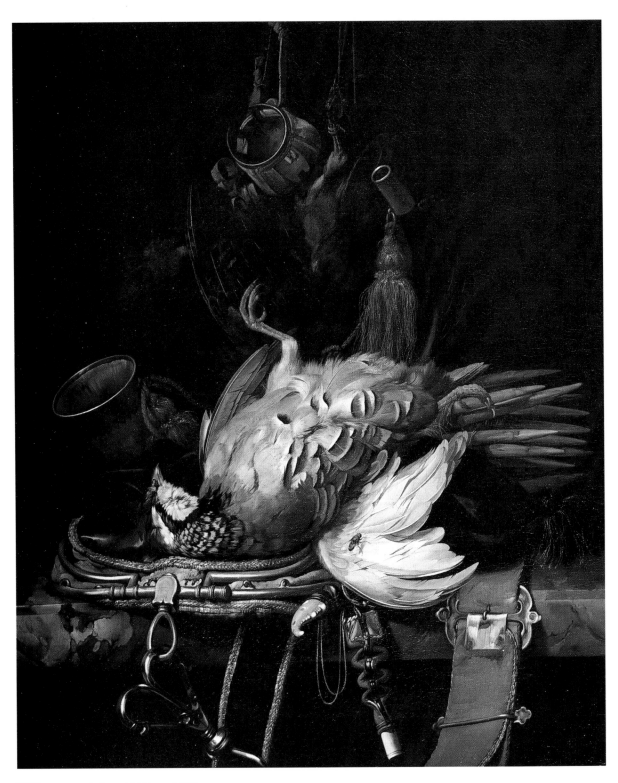

Willem van Aelst, 1627-c. 1683
Hunting still life with dead partridges, 1671
Canvas, 58.8 x 47.8 cm
Inv. no. 3

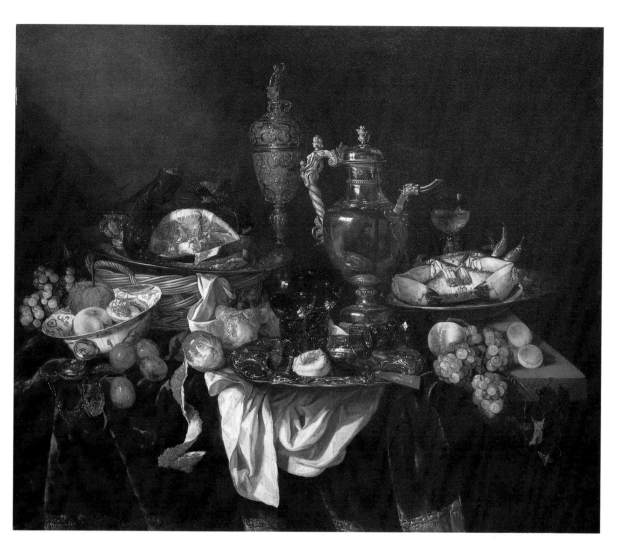

Abraham van Beyeren, 1620/1621-1690
Ornamental still life, after 1655
Canvas, 99.5 x 120.5 cm
Inv. no. 1056

Jan Baptist Weenix, 1621-1660/1661
Dead partridge, c. 1655/1660
Panel, 50.6 x 43.5 cm
Inv. no. 940

Van Ruisdael and the landscape artists

There is no more typically Dutch subject for a painting than a flat summer or winter landscape, and Holland has a long tradition of landscape painting from Hendrick Avercamp to Jacob van Ruisdael. Before the Golden Age, landscapes were used mainly as backgrounds for biblical or mythological scenes (illustration p. 46). In his *Schilder-Boeck* (1604, see p. 48), the painter and biographer Carel van Mander predicted that some artists would start to specialize in particular subjects such as landscapes or still lifes. Avercamp painted one of the earliest examples of a pure landscape (illustration p. 118) in about 1610. He dispensed with the pretext of depicting a tale from the Bible set in winter, or a representation of one of the seasons, and so we are left to enjoy the little details: the family which has fallen through the ice, the women who has fallen over while skating and given us a view up her dress, and the dandy who cuts a dash even on his somewhat unsteady skates.

Not long afterwards, Pieter van Santvoort painted typically Dutch landscapes with scenes set amid dunes (illustration p. 119). The restrained use of colours, and the figures added almost as an afterthought, were the most distinctive feature of these works. They marked the beginning of a period of landscapes painted in a single tone, of which Jan van Goyen was one of the greatest proponents (illustration p. 119). Half a century later, Jacob van Ruisdael painted a summer in Holland (illustration p. 122). We are looking from the dunes near Haarlem at the fields where linen is laid out to bleach in the sunlight, which falls like a spotlight through gaps in the clouds.

Landscapes displayed a great variety of subject matter. Aert van der Neer specialized in night scenes and moonlit landscapes (illustration p. 126). Meindert Hobbema often repeated details and effects of light, by which he particularly liked showing that, like many other landscape artists, he painted in a studio (illustration p. 120). This could not be more different from the almost photographic depiction of a canal in Amsterdam by Jan van der Heyden, who painstakingly painted every individual brick of the houses on the Bierkaai (illustration p. 121).

One unifying feature of all Dutch landscapes is the sky. In the work of artists such as Jacob van Ruisdael, the larger part of the painting consists of bright blue skies and cotton-wool cloud formations. Jacob's uncle, Salomon van Ruysdael, was also a master at painting skies (illustration p. 123). Jan van de Cappelle, who was an amateur painter, created imposing blue-grey or silvery cloud formations (illustration p. 124). His teacher, Simon de Vlieger (illustration p. 124), painted tonally in the style of Jan van Goyen (illustration p. 119), seeking his effects mainly from shades of grey.

Apart from those who painted river and beach scenes, there were also artists who concentrated on seascapes. Willem van de Velde the Younger chose water as his motif (illustration p. 125), as did his father who also specialized in closely observed portraits of ships. Father and son went to work for King Charles II of England in the disastrous year of 1672. They were the best-known portrayers of the glorious seafaring past of Holland and England.

Willem van de Velde the Younger, 1633-1707
Ships on calm water (detail; see p. 125)

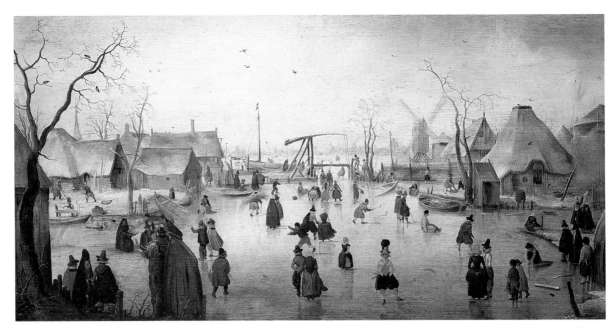

Hendrick Avercamp, 1585-1634
Pleasure on the ice, c. 1609/1610
Panel, 36 x 71 cm
Inv. no. 785

Esaias van den Velde, 1587-1630
Winter landscape, 1624
Panel, 26 x 32 cm
Inv. no. 673

Jan van Goyen, 1596-1656
Winter landscape, 1626
Panel, 32.5 x 50 cm
Inv. no. 1094

Pieter Dircksz van Santvoort, 1604/1605-1635
Dune landscape with country road, c. 1625/1630
Panel, 31.5 x 46 cm
Inv. no. 1096

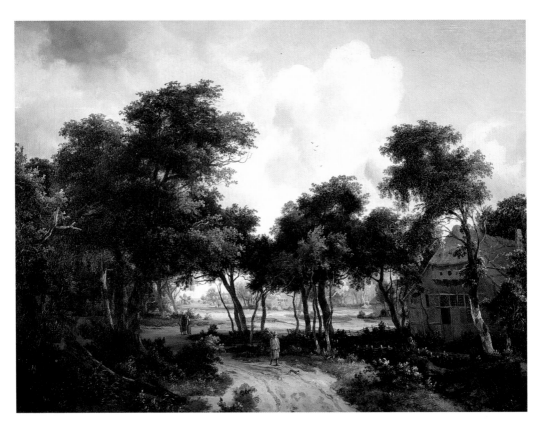

Meindert Hobbema, 1638-1709
Timber-frame houses under trees, c. 1660/1670
Panel, 53 x 71 cm
Inv. no. 1061

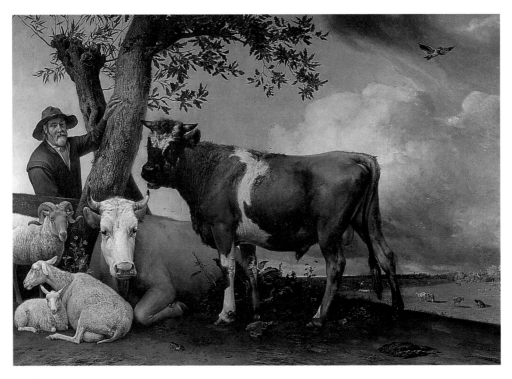

Paulus Potter, 1625-1654
The bull, 1647
Canvas, 235.5 x 339 cm
Inv. no. 136

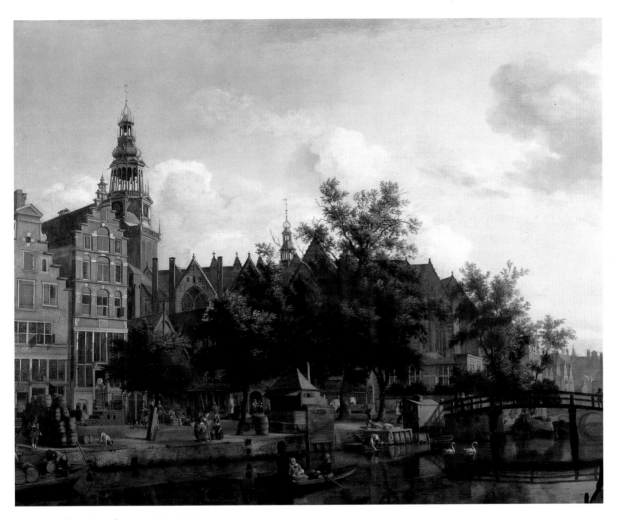

Jan van der Heyden, 1637-1712
View of the Oudezijds Voorburgwal with the Bierkaai and the Oude Kerk in Amsterdam, c. 1670
Panel, 41.2 x 52.5 cm
Inv. no. 868

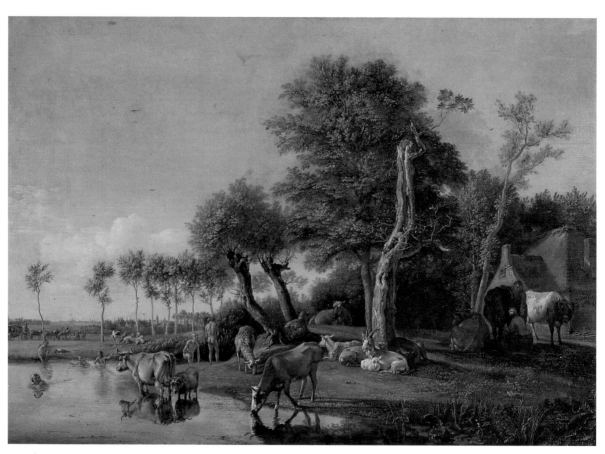

Paulus Potter, 1625-1654
Cows reflected in the water, 1648
Panel, 43.4 x 61.3 cm
Inv. no. 137

**Jacob van Ruisdael,
1628/1629-1682**
*View of Haarlem with the
bleaching-fields*, c. 1670/1675
Canvas, 55.5 x 62 cm
Inv. no. 155

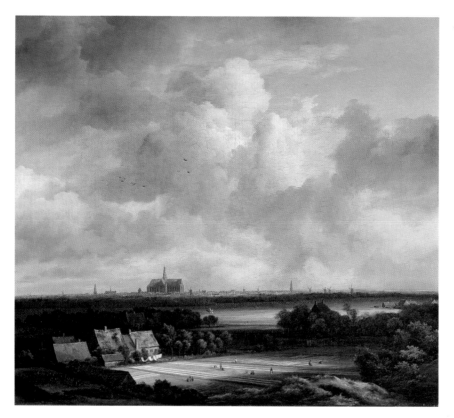

Salomon van Ruysdael, c. 1600/1602-1670
River view, c. 1648
Panel, 47.3 x 69 cm
Inv. no. 699

Jan van de Cappelle, 1616-1679
Ships on the coast, 1651
Canvas, 72.5 x 87 cm
Inv. no. 820

Simon de Vlieger, c. 1601-1653
Beach view, 1643
Panel, 60.6 x 83.5 cm
Inv. no. 558

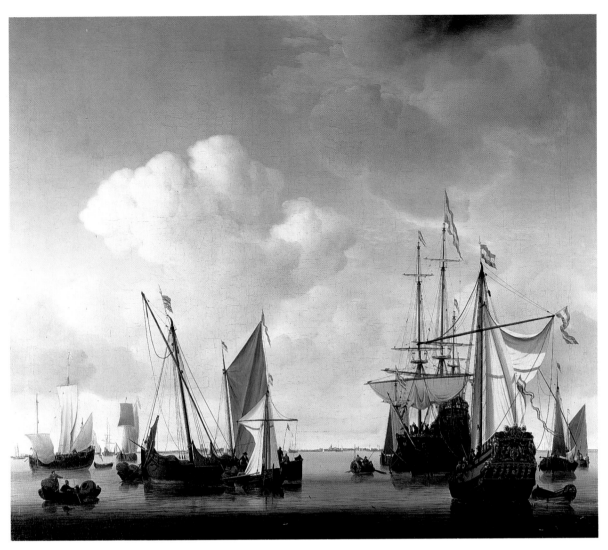

Willem van de Velde the Younger, 1633-1707
Ships on calm water, c. 1658
Canvas, 66.5 x 77.2 cm
Inv. no. 200

Frans Post, c. 1612-1680
Itamaraca island, 1637
Canvas, 63.5 x 88.5 cm
Inv. no. 915

Aert van der Neer, 1603/1604-1677
River landscape by moonlight, c. 1650/1655
Panel, 44.8 x 63 cm
Inv. no. 913

Salomon van Ruysdael, c. 1600/1602-1670
River landscape, c. 1645/1650
Panel, 75 x 106.5 cm
Inv. no. 738

Index